THE
ART
OF
THE

ILLUSION

DECEPTIONS
TO CHALLENGE
THE EYE AND
THE MIND

BRAD HONEYCUTT & TERRY STICKELS
FOREWORD BY SCOTT KIM

imagine!
Publishing

DEDICATION

Dedicated to the memory of Jos de Mey (1928–2007)

"Art that only satisfies the mind is interesting. Art that only satisfies the eye is superficial.
That's why I always look for art that is both interesting and aesthetically satisfying." —Jos de Mey, 1998

An Imagine Book
Published by Charlesbridge
85 Main Street
Watertown, MA 02472
(617) 926-0329
www.charlesbridge.com

Library of Congress Control Number: 2011942279

ISBN 13: 978-1-936140-71-8

Printed in China. Manufactured in March, 2012.
(hc) 10 9 8 7 6 5 4 3 2 1

Designed by Melissa Gerber

For information about custom editions, special sales, premium and corporate purchases, please contact Charlesbridge Publishing at specialsales@charlesbridge.com

To order Rob Gonsalves' work, contact Huckleberry Fine Art at 301-466-9344. The website address is www.huckleberryfineart.com. The email address is info@huckleberryfineart.com.

CONTENTS

Foreword.. 5

Introduction .. 10

Gallery .. 19

 Epilogue...220

 Artist Websites ...222

 Acknowledgments223

 Index ..224

FOREWORD

Art is a lie that makes us realize truth. — *Pablo Picasso*

Welcome to *The Art of the Illusion*, the richest and most diverse collection of illusionary art ever assembled in one book. Flip through the pages and you'll find works by established masters such as Dutch artist M. C. Escher, as well as innovators like Gianni A. Sarcone who take classic ideas in fresh new directions. You'll find scientists such as the dazzling Akiyoshi Kitaoka next to fine artists like the austere José María Yturralde. You'll also find diverse styles from all over the world, from the gentle, camouflaged landscapes of Russian artist Elena Moskaleva to the bold, graphic conundrums of Malaysian illustrator Chow Hon Lam.

This book was written by Brad Honeycutt and Terry Stickels. Terry is a puzzle designer, best known for his *Frame Games, Stickdoku,* and *S-T-I-C-K-E-L-E-R-S* newspaper columns, as well as many books. To locate artists for this book, Terry teamed up with the knowledgeable Brad Honeycutt, proprietor of the extensive illusionary art web site, www.eyetricks.com. Together, they searched the world to find the best artists and illusions. Many of the artists have online portfolios; I encourage you to look up your favorite artists to see more of their work. (For a list of artist websites, see page 222.)

Like Terry, I am a puzzle designer. Over the years Terry and I have enjoyed a collegial relationship, exchanging ideas and encouragement. We share a fondness for puzzles that exercise spatial thinking and creative problem solving skills. I also create illusionary art. So when Terry decided to write this book, he invited me into his circle of advisors.

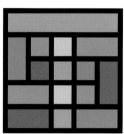

Illusions and puzzles have much in common. Both seek to delight your mind and engage your curiosity. Here is a logo I designed for Terry that is both an illusion and a puzzle. At first it looks like a collection of colored rectangles. Look again and you will see two superimposed letters—Terry's initials, T and S. That's the illusion. Now the puzzle: how many squares of any size are in this design? Don't forget to count the big square that outlines the whole logo. For the answer, see page 220, or visit www. terrystickels.com.

There are many books of illusionary art. What makes this book special is that it contains a very wide variety of artists and styles. I've enjoyed seeing how different artists have tackled the same illusions, and used the same devices to express different ideas. Here are some of my favorite comparisons.

DEPTH

A gimmick in the hands of one artist can become poetry in the hands of another. Here are two images based on the principle of depth ambiguity. In both images, objects that appear to be near and far are brought into contact with each other. Both images delight me, but for very different reasons.

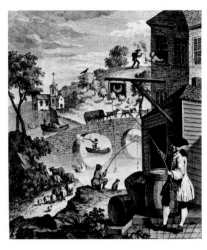

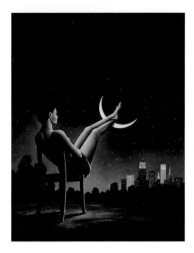

This classic engraving by William Hogarth is chock full of visual impossibilities. It reminds me of a flashy, three-ring circus. Look here! Look there! See the amazing candle-lighting and curving bullet! Find all the tricks! The visual acrobatics take center stage here.

This painting by Rafal Olbinski focuses on just one visual impossibility. What a fantasy, to be able to rest your feet on the moon, as if it really were a crescent! Visual acrobatics are still present here, but play a supporting role. This image reminds me of the performance group Cirque du Soleil, which dresses classic circus acts in tribal music and other-worldly costumes to create a mystical cosmic dance.

STAIRS

Stairs are popular elements in illusionary art—they appear at least twenty times in this book—because of their rich visual possibilities. Let's look at how two artists used stairs to create two very different moods.

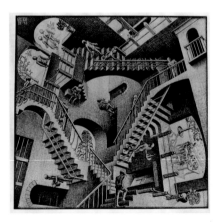

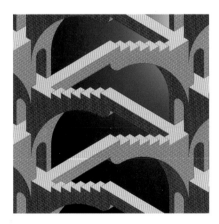

M. C. Escher populates his gravity-defying world of stairs with three different groups of people, each oblivious to the other two groups. As I scan the image, I imagine the path each person walks, and wonder what they must be thinking. The carefully modulated grays and precisely rendered perspective create a tangible reality that is calm, even mundane, but bizarre.

Jos Leys nightmarish space is raw architecture. With no inhabitants to humanize the space, the image assaults me with bright colors, flat perspective, and the unsettling suggestion that the repetition goes on forever. I wonder for whom this space was built. Notice that this structure is drawn so that going up the stairs takes you downstairs. Escher's structure has no such twist.

AMBIGUITY

Rob Gonsalves and Octavio Ocampo are masters of ambiguous imagery. Both paint rich scenes that can be interpreted in more than one way, but they guide the eye of the viewer in very different ways.

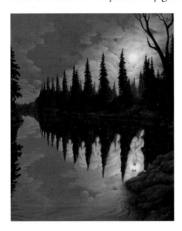 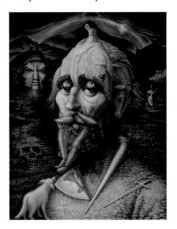

In this painting, Rob Gonsalves guides your eye from left to right as the space between the trees, reflected in the water, gradually changes shape to become a procession of women emerging from a lake. Your eye scans back and forth, looking in vain for the precise moment when the transformation takes place. The effect is cinematic, strongly suggesting a story.

In this painting by Octavio Ocampo, the two interpretations hit you all at once, like the notes of a chord. Rather than guiding your eye, the artist lets you explore the layers of images on your own time. The effect is less like following a story than digging through layers of symbolism.

FLAT VERSUS DIMENSIONAL

Making flat images appear three-dimensional has fascinated artists since the Renaissance. Here are two clever new takes on the play between two and three dimensions.

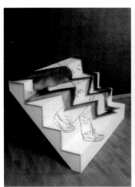 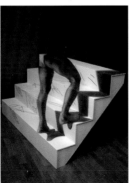 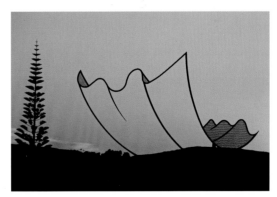

This sculpture by István Orosz changes appearance depending on where you stand. From one point of view, the black and white lines drawn on the stairs appear to be a man walking down the stairs. From another point of view, the colored areas align to form the legs of a man walking up the stairs.

This monumental sculpture by Neil Dawson bounces back and forth between two and three dimensions many times. Consider: this is a two-dimensional photograph of a three-dimensional sculpture of a two-dimensional drawing of a three-dimensional object—an object that happens to be a two-dimensional sheet with three-dimensional ripples.

AMBIGRAMS

Ambigrams are words written so they can be read in more than one way, usually right side up and upside down.

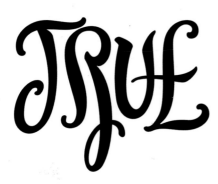

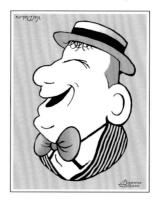

This ambigram by John Langdon reads TRUE right side up, and FALSE upside down. As in other ambiguous images, each element serves more than one function: the U upside down becomes a round A, the E in TRUE becomes a cursive F in FALSE, and so on. Notice how different parts of the letters play different roles when the word is flipped over: the right side of the crossbar of the T becomes a flourish at the bottom of the E in FALSE.

This drawing by Russian cartoonist Valentine Dubinin "reads" as a face both right side up and upside down, just like an ambigram. Again, each element serves more than one function: the nose becomes a chin (and vice versa), the hat becomes a collar, and the mouth and ear become themselves. Notice how different parts of the drawing play different roles when the face is flipped over: the lines denoting squinty eyes turn into the edge of a jaw, and the bowtie with creases turns into tinted glasses over closed eyes. It takes a good deal of work to compose an invertible face (or ambigram) that works together this well.

PHOTOGRAPHY

I was pleasantly surprised to see photography throughout this book. Although I've seen a few photographic illusions in the past, I've never seen so many.

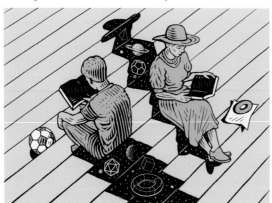

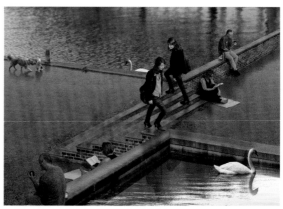

Here is a lovely drawing of a classic staircase illusion by the versatile István Orosz in which the diagonal lines are alternately interpreted as edges or creases. Note that the stairs are not shaded; all of the dimensional information comes from the shadows and the way people and objects sit on the stairs.

Here is David Macdonald's photographic interpretation of the same illusion. Notice how the steps are shaded light and dark on the right end to indicate horizontal and vertical surfaces, but fade to a more uniform value at the left end where they are all top surfaces. More than a dozen other illusions in this book incorporate photography.

INNOVATIONS

Finally, here are two inventive illusions that suggest ideas for future innovation.

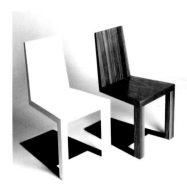

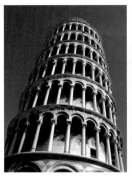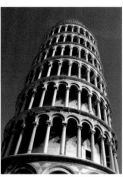

These shadow chairs by Christopher Duffy cleverly incorporate a striking illusion into an everyday object. The shadows are, in fact, parts of the chairs. What other illusions can be worked into household objects? Can you imagine impossible silverware? Paradoxical bookcases? Ambiguous doors?

You might think that every possible optical illusion has been discovered, yet new illusions are found every year. This illusion by Fred Kingdom won the Best Illusion of the Year Contest in 2007. The two photos are identical, even though the tower on the right appears to lean farther. What other new illusions await discovery?

—Scott Kim
 Puzzle Designer and Author of *Inversions*

INTRODUCTION

*"Only those who attempt the absurd will achieve the impossible. I think it's in my basement...
let me go upstairs and check."*

— M.C. Escher (1898–1972)

W e have never met anyone who did not enjoy a great magic trick. It is simple to see why. There is nothing more delightful than being playfully fooled while, at the same time, trying to figure out how it could happen so quickly and cleverly. You feel as though your mind's eye is blinking at the speed of light to catch up to the image or magic in front of you. And it is. To us, optical illusions are magic. Take a good look at the painting below by Rob Gonsalves and you will instantly know what we mean.

CATHEDRAL OF COMMERCE BY ROB GONSALVES, 2004

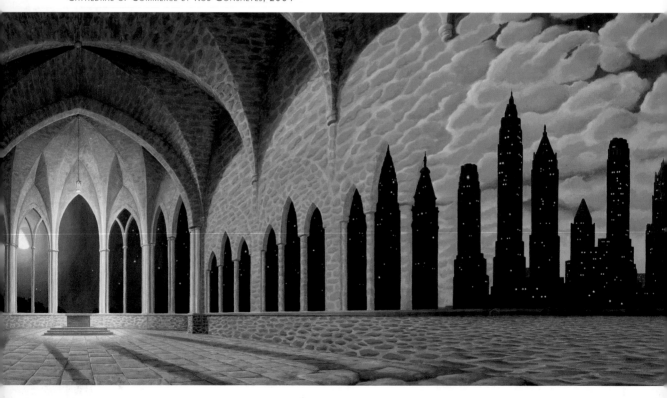

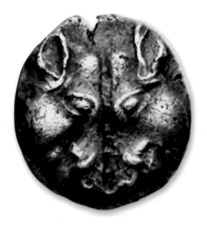

Optical illusions are universally enjoyed, and can be appreciated on multiple levels. From sheer fun and silliness to mathematical concepts to fine art, optical illusions have delighted readers from ages 5 to 105. Optical illusions are used in psychology and neuroscience to investigate how our minds interpret different images. The field of philosophy also studies optical illusions, where errors of perception are studied in terms of the schools of realism and how our minds perceive objects. Optical illusions even occur in nature, when the setting sun mystically becomes three or four times larger while resting on the horizon. In reality, the sun is always the same size.

Optical illusions did not mysteriously jump off the canvas in the 1960s with the paintings of Victor Vaserly, Bridget Riley, and M.C. Escher. Quite the contrary: people have been fascinated and entertained by optical illusions for thousands of years.

The history of optical illusions has an irregular, up and down pathway to the present. There are long periods of apparent inactivity, or at least little evidence of it in the form of art or architecture. The earliest documented illusion appears in the form of a coin found on the Island of Lesbos around 2500 B.C. In the picture of the metal coin above, you can see an image of two bulls facing each other. If you take a second look, it can also be perceived as a wolf's face staring straight ahead.

Portraying three-dimensional objects on a two-dimensional canvas is the backbone of both Western art and simple illusions. Taking this one step further, artists began to intentionally deceive the viewer into believing his or her fictional creation was real, however briefly. In essence, you had a "double dip" illusion: three dimensions on a two-dimensional canvas with the visual trickery incorporated into that canvas. There is evidence to suggest intentional illusions were first used in ancient Greece and later picked up by the Romans. While other forms of optical illusions became popular beginning in the 14th century, this form of art vanished for a time and reappeared in the Netherlands in the 17th century. This art form came to be known as *Trompe l'oeil*, a French term meaning *"trick the eye."* The ancient Greeks even demonstrated their awareness of optical illusion effects through their architecture, designing the columns of buildings like the Parthenon bulge so that from a distance they appeared perfectly straight. The Greeks understood that the proper slant of roofs also had an illusory effect on observers by creating the appearance of the building standing more erect than it actually was.

"TO US, OPTICAL ILLUSIONS ARE MAGIC"

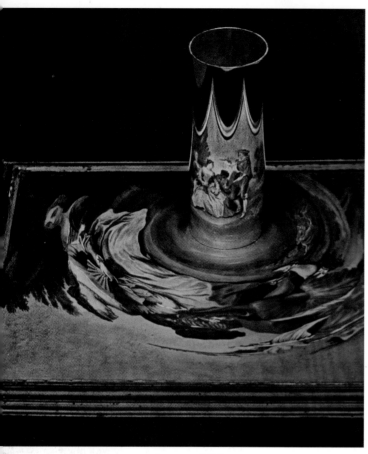

Title Unknown by Laurente, 1630

There is little mention of optical illusion art from ancient times through the Dark Ages. It seems to have reappeared in full force during the Renaissance. This era marks the beginning of many different types of illusory art. During this period, artists began to explore and fully comprehend linear perspective, and they were the first to realize that parallel lines can merge to give the feeling of depth. Using different hues, shading, and image sizes, their paintings looked more realistic than their predecessors. They explored new techniques to show and distort perspective so that the brain might interpret an image in two completely different ways.

In the late 1400s, Leonardo da Vinci is given credit for an art form known as *anamorphosis* or "slant art," which requires the viewer to either occupy a certain vantage point to see the image properly or to employ the use of reflection in a conical, cylindrical, or pyramidal mirror to get the right view. As an example, in its original form on canvas, the image is distorted so significantly that viewer cannot even offer a guess as to what they're looking at until it's viewed from the perfect angle where the image reveals itself as the artist intended. *Anamorphosis* became extremely popular and was a means where questionable material or politically sensitive messages could be hidden. It remains quite popular today. An example of this type of art that combines elements of a puzzle combined with magic is provided above.

The other type of illusory art that became popular during the Renaissance is called "double imagery" or "double meaning." This illusion form was made popular by Giuseppe Arcimboldo, an Italian painter who did most of his work in the mid to late 1500s. His work featured fruits, animals, vegetables, fish, and other objects molded together in such a manner that created a highly accurate human portrait. If you moved in for a closer look, you could see the myriad of objects he painted to comprise the image. His work was considered so revolutionary that some art

critics thought his creations to be a manifestation of mental illness. But Arcimboldo was simply an immensely talented individual who embraced this illusionary art form. Evidence of his sanity exists in the form of his traditional artwork. While his traditional art was lost through the years, his double-meaning work reappeared in the early 20th century. These paintings had a tremendous influence on surrealist artists such Salvador Dali, and Arcimboldo still has a strong influence today. You will see wonderful double-meaning works in this book from several talented artists.

During the late 19th and early 20th centuries, double-meaning or metamorphic art again became popular and was used extensively on postcards and in advertisements. Scores of illustrators created these visual puns, which often featured dark themes and subject matter including skulls, devils, and other taboo topics. One classic example from George A. Wotherspoon titled *Society, a Portrait* (see following page) features a gentleman escorting a woman on each of his arms. Closer inspection of the portrait, however, reveals that the man's chest and arms also resemble the head of a donkey.

No other artist has contributed more to the popularity of optical illusions and mathematical

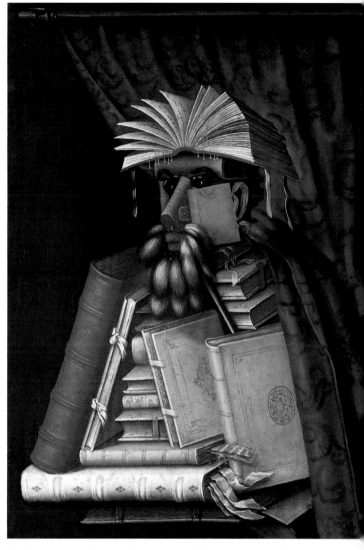

THE LIBRARIAN BY GIUSEPPE ARCIMBOLDO, 1562

art than M.C. Escher. Maurits Cornelis Escher was born at the end of the 19th century in Leeuwarden, Holland. He initially studied architecture but switched to the arts, becoming proficient in drawing and woodcarving. As a young man in his twenties, he traveled extensively through Europe and during this time visited the Alhambra, a Moorish castle in Spain. He was fascinated with the Moors' way of segmenting planes into repeating periodic shapes with colors. The Moors were forbidden by their religion to use images of living organisms in their art, and Escher thought how

dynamic congruent patterns of birds, fish, humans, and other living things might appear when tiled together. Thus began his work in tessellations—the symmetrical technique of tiling a plane—and the broad spectrum of different and sometimes shocking images he would go on to create during his lifetime. Escher was one of the first artists to explore the art concept of infinity on a plane, working in level of detail that created more than parallel lines disappearing on the horizon. This led to his famous *Circle Limit* series of wood engravings, which became some of his most popular work.

By the 1950s, M.C. Escher had become famous in Europe, but was still relatively unknown in the United States. He wrote *The Regular Division of the Plane* in 1958, a book that discussed some of the math behind his work. "Mathematicians have opened the gate leading to an extensive domain," he commented in the book. Escher's work was the first in history to build the bridge between mathematics and art, fortified by solid mathematical constructs. The beauty of all this is that an individual can enjoy the fun and pleasure of his creations while exploring the mathematical applications at the same time. Symmetry, periodic tiling of the plane, platonic solids, hyperbolic geometry, topology, group theory, and crystallography can all be found and studied in Escher's diverse body of work.

Escher's popularity was just reaching critical mass when he died in 1972. Today,

SOCIETY, A PORTRAIT BY GEORGE A. WOTHERSPOON, EARLY 20TH CENTURY

he is more popular than he ever was during his life. Bookmarks, calendars, t-shirts, posters, and more can be readily found across the retail landscape in virtually every country.

In the 1960s, the term "op art" was coined in an article appearing in *Time* magazine, and came to be the catch-all phrase for optical art and illusions of all kinds in the years following. After a major exhibit at the Museum of Modern Art in New York, which received significant coverage in 1965, op art became hugely popular with the general public. Images of op art were seen on television, in newspapers, graffiti, album covers, clothing, and advertising of all kinds. Hungarian born Victor Vaserly is often cited as the father of this movement with Bridget Riley, Yaacov Agam, and Josef Albers as other notables. Salvador Dali, although known by most as a surrealist painter, created some excellent op art paintings that are still popular today. Much detail has been given to discussing the aspects of what constitutes op art, but the number one feature is *trompe l'oeil*. Op art is a form of abstract art where lines, space, and color are integrated into symmetrical forms. The lines are simple and repetitive, and sometimes include unusual shading and coloring that give the art its beauty and excitement. Often, some of the art seems to have an almost uneasy feeling of depth, while at the same time possessing a pleasing sense of simplistic beauty.

Op art saturated everything for about 5 years, and even though its intensity leveled off, it is still popular today. One of the reasons is that computers are a perfect medium for designing and creating op art style imagery. One can see evidence of this on the Internet and on many websites that use op art as logos. Of course, the masters did their creations by hand, which is amazing when you consider what goes into creating even one of these images.

During the 1970s, two men simultaneously (but unknown to each other at the time) launched a barrage of clever design creations on the American public. Scott Kim and John Langdon each believed they had invented these designs independently of one another. These designs would later be dubbed "ambigrams" in the early 1980s by Douglas R. Hofstadter.

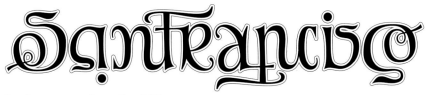

San Francisco by Scott Kim, 2011

An ambigram is a form of art that presents two or more different words within the same physical space through a mix of illusion and symmetry. The different words can be viewed by looking at the design from another perspective (such as upside down or reversed). There are several different types of ambigrams, but popular categories of this art include rotational ambigrams (a design that can be rotated by some angle to present a different instance of a word), mirror image ambigrams (a design that can be read when reflected in a mirror) and figure-ground ambigrams

(a design that has one word embedded within the spaces of another word). The illusion on the previous page is a rotational ambigram above, and looks exactly the same when viewed upside down, while the image below is a figure-ground ambigram that presents two distinct words in the same space.

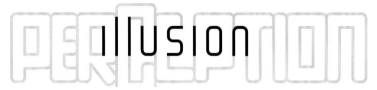

Peter Newell is given credit as the creator of the first ambigram—his designs were pictures that could be inverted. His book *Topsy & Turvys*, released in 1893, featured pictures on each page that could be turned upside down to reveal a completely different (but recognizable) image. The last page of his book featured a drawing that reads "THE END" when viewed in one direction and "PUZZLE" when viewed upside down. These types of puzzles remained popular in both England and the United States throughout the early 1900s. Books, postcards, magazines, and posters were dedicated to this genre, and were enjoyed by both kids and adults.

Kim was the first to put motion to his ambigrams by spinning several of his creations to reveal their duality. Langdon made ambigrams even more popular when his designs were incorporated into the plot of Dan Brown's bestselling novel *Angels & Demons*. Brown thought so highly of Langdon he named the hero of his book Robert Langdon in his honor. Originally, both men made all their designs by hand. This would change with the increased use of computers and it was a natural evolution for both men to augment even more brilliant creations using digital enhancements. Computers have given this type of illusion an unlimited panorama for new creations, and one can only imagine what lies ahead.

Today's optical illusion landscape is an amalgamation of the aforementioned types along with a new generation of artists and their creations. With the ability to create illusions using a computer and a variety of commercially available software, contemporary illusion artists take on a new dimension not available to those in the past. Static images can now be made to move, or at least *appear* to move, as we all know that a photograph cannot actually be in motion, right? Perhaps you should judge for yourself by studying the image at right.

One of the interesting aspects of current-day op art is that there is even more emphasis on illusions and their interrelationship with math, science, neuroscience, graphic design, and the entire broad spectrum of the arts. As evidence of this, the 2010 winner of the Best Illusion of the Year Contest is a mathematical engineer who created a now well-known illusion of balls rolling uphill. An article appearing in the May/June 2011 issue of *Scientific American*

MIND discusses the contest and offers the following: "Whereas scientists once created illusions from simple lines and shapes and artists focused on making eye-popping illusions, the overlap between science and art is now greater than ever. Scientists are using graphic design tools to make their illusions more artistic, and artists have grown more knowledgeable about the neuroscience behind the magic."

It should go without saying that artists will continue to push the boundaries of illusionary effects going forward. In fifty years time, an entirely new breed of illusions may exist, and people will love them because we all enjoy being fooled. In compiling this book, we were fortunate enough to get to know many of the wonderful artists who appear within these pages. Some are mathematicians fascinated with symmetry and some are vision researchers in search of answers. Others are graphics designers and painters who desire to push the boundaries of what can be done on a flat surface or canvas. Ultimately, however, they are all masters at creating art that both fascinates and deceives. If you, the reader, have even half as much fun browsing through this collection of images as we did compiling them, then we will have done our job.

—Brad Honeycutt and Terry Stickels

UNTITLED BY PAUL NASCA, 2010

GALLERY

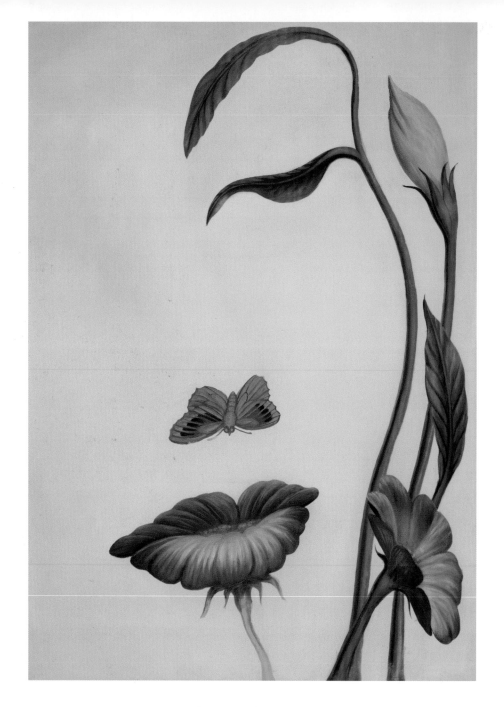

OCTAVIO OCAMPO

Mouth of Flower

The humble flower and its buds meeting a butterfly, as often happens in nature, serve to give us a hint of Mother Nature's face.

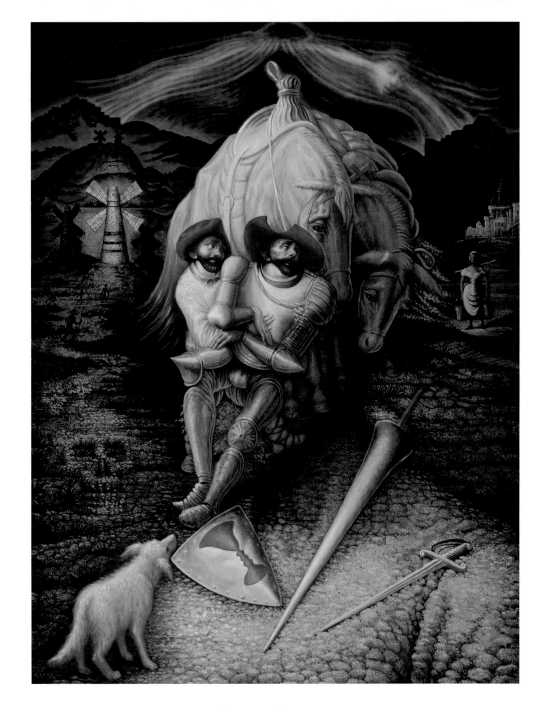

OCTAVIO OCAMPO

Friendship of Don Quixote

Two men resting their horses by the road resemble a portrait of Cervantes' famous protagonist Don Quixote.

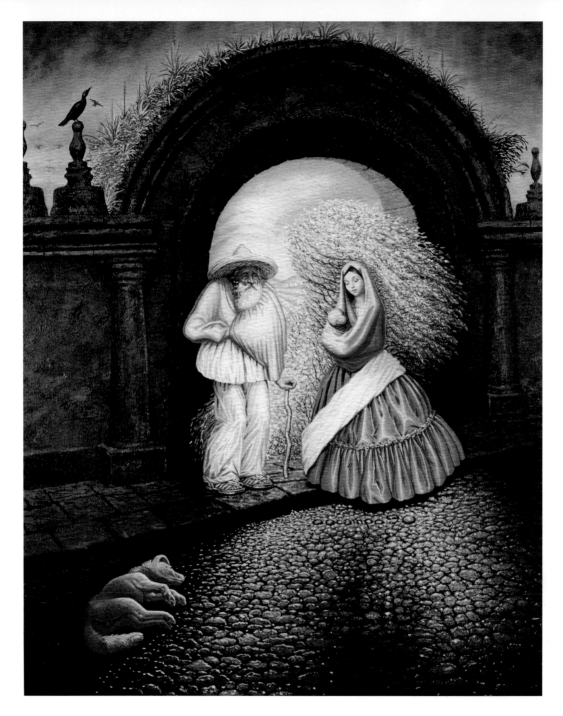

OCTAVIO OCAMPO

General's Family

The General's family, depicted in this painting, form a scene with a striking resemblance to the General himself.

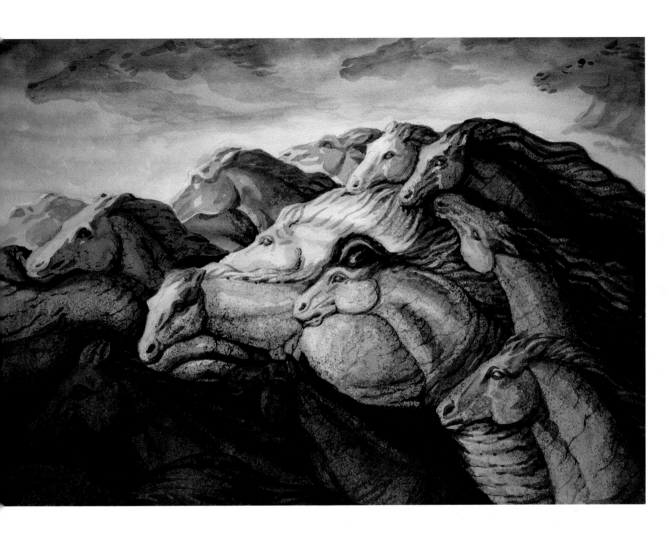

OCTAVIO OCAMPO

To Run with the Herd

A herd of wild horses form a surreal scene comprised of both a larger equine and a mountainous landscape.

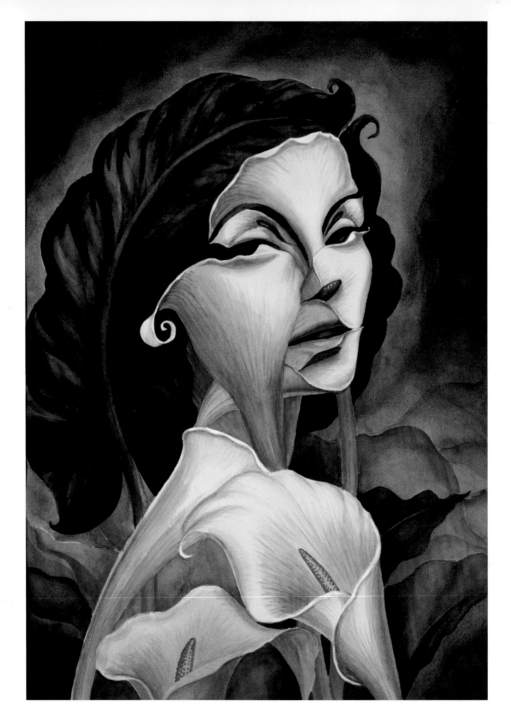

Octavio Ocampo

Woman of Substance
A beautiful young woman hides among the flowers and leaves.

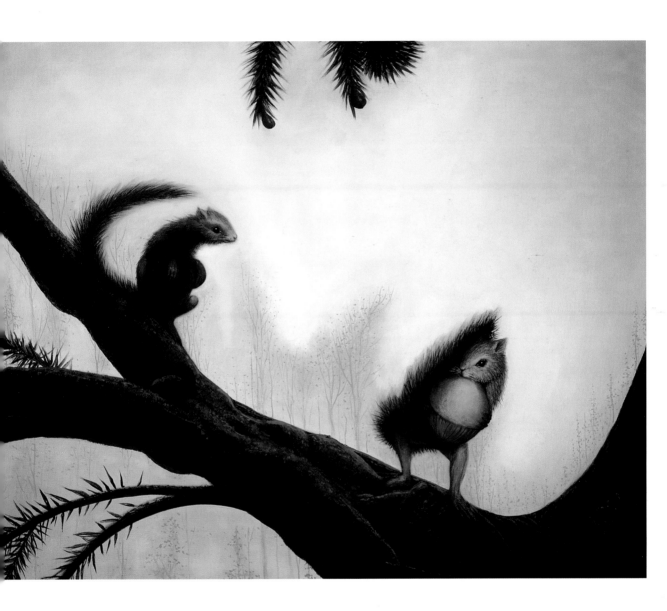

OCTAVIO OCAMPO

Squirrels of the Tree
The ominous presence of a young woman looms over two squirrels in search of acorns.

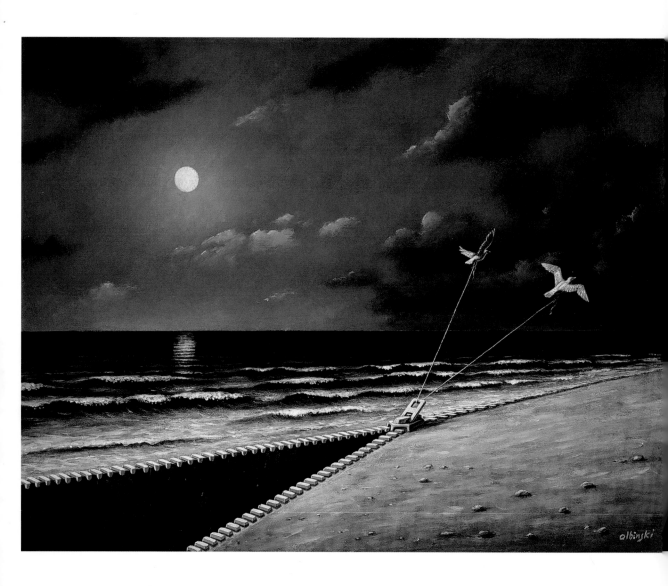

RAFAL OLBINSKI

The Weight of the Rising Tide, 1996

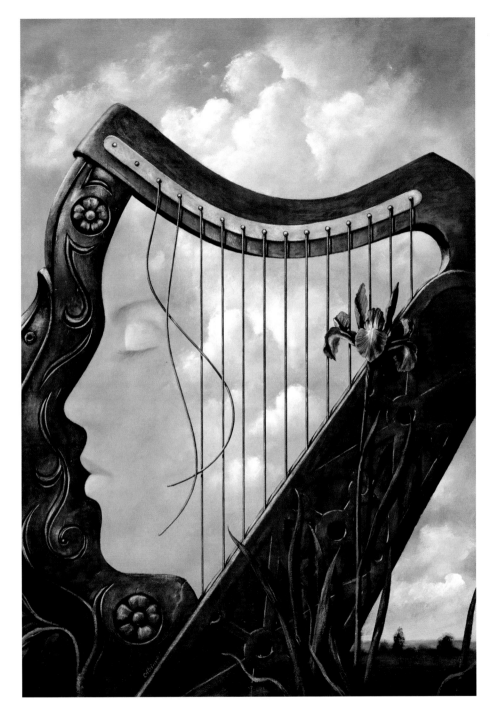

RAFAL OLBINSKI

Iris, 1995

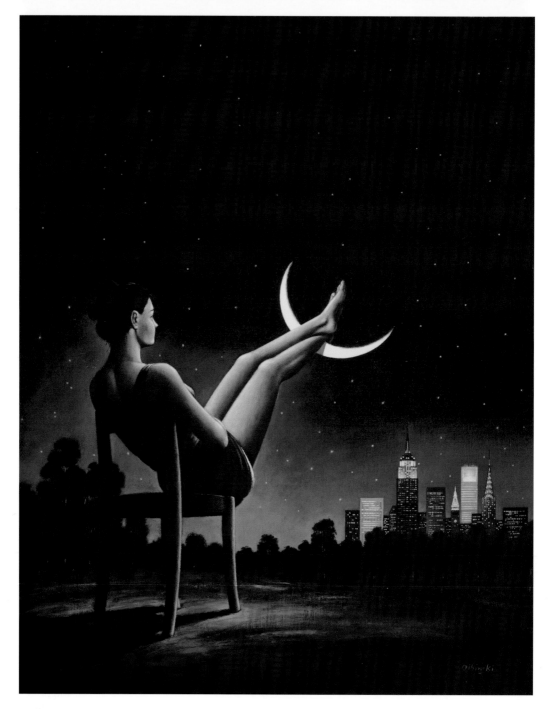

Rafal Olbinski

Third Dimension of Time, 2002
Perspective and fantasy collide as a woman uses the moon as her very own nocturnal footrest.

M.C. ESCHER

Development II, 1939

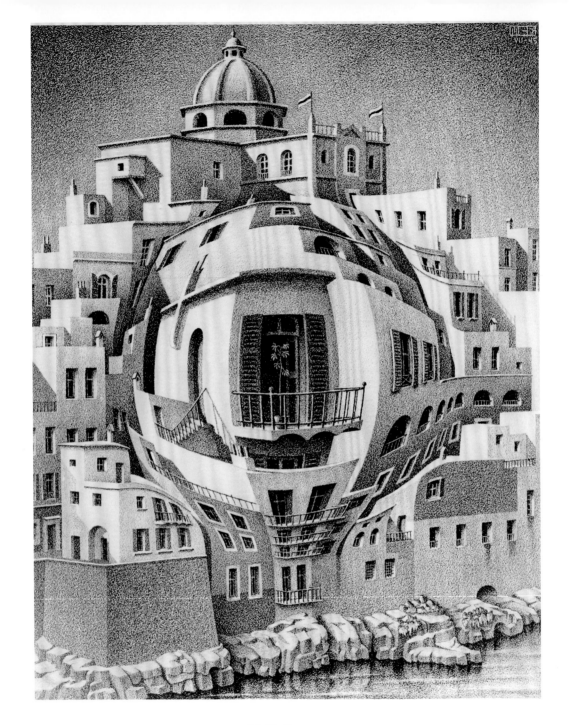

M.C. ESCHER

Balcony, 1945

M.C. Escher's magnification of the balcony in the center of this drawing gives the entire image a great sense of depth.

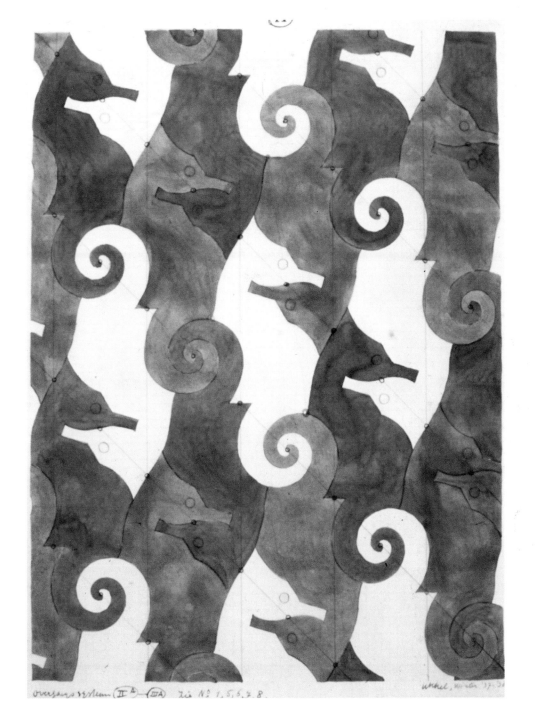

M.C. ESCHER

Symmetry Drawing E11, 1937-1938

Many of M.C. Escher's works use tessellations (tilings). In this example, a series of red, white, and blue seahorses come together to fill the plane without overlaps or gaps.

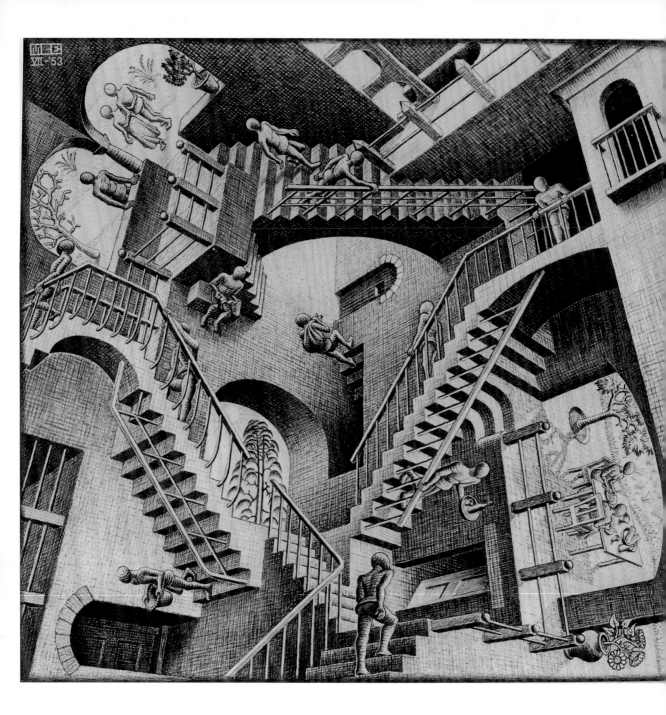

M.C. ESCHER

Relativity, 1953

Conventional laws of gravity are shattered as people come and go in all directions. Studying this popular work of art can lead to more questions than answers.

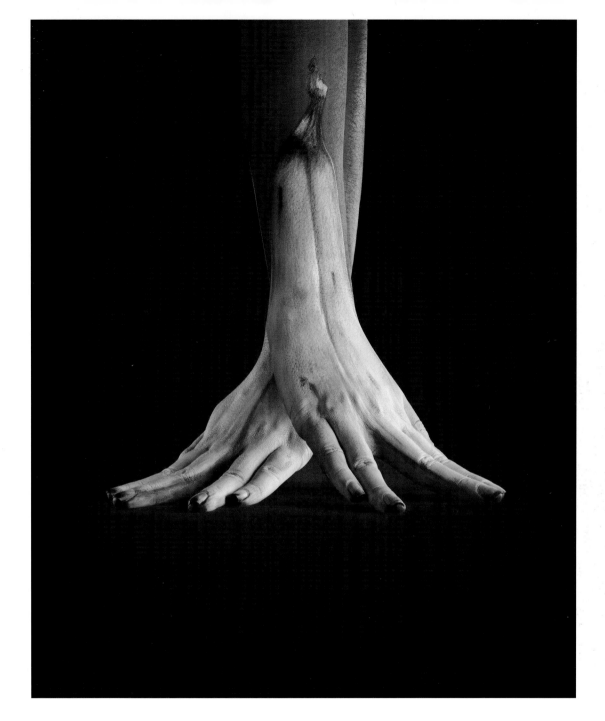

RAY MASSEY

Banana Hands, 2009
Skillfully painted hands and fingers create the illusion of a peeled banana resting on a table.

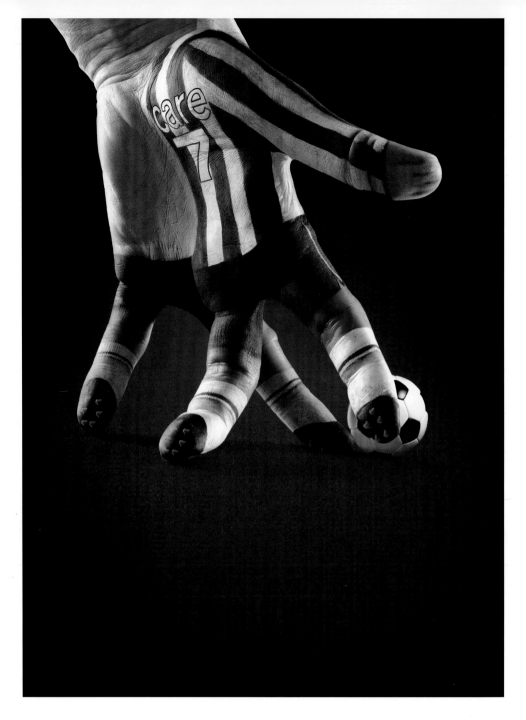

RAY MASSEY

Footballers, 2009

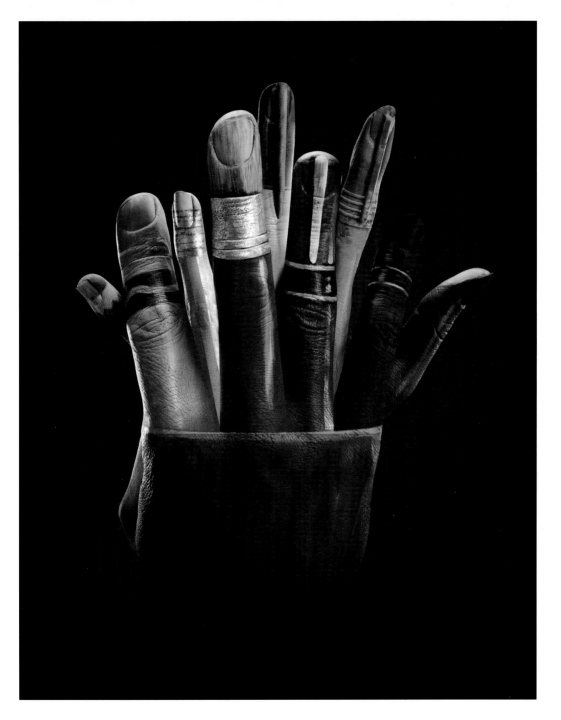

RAY MASSEY

Pencil Pot, 2009

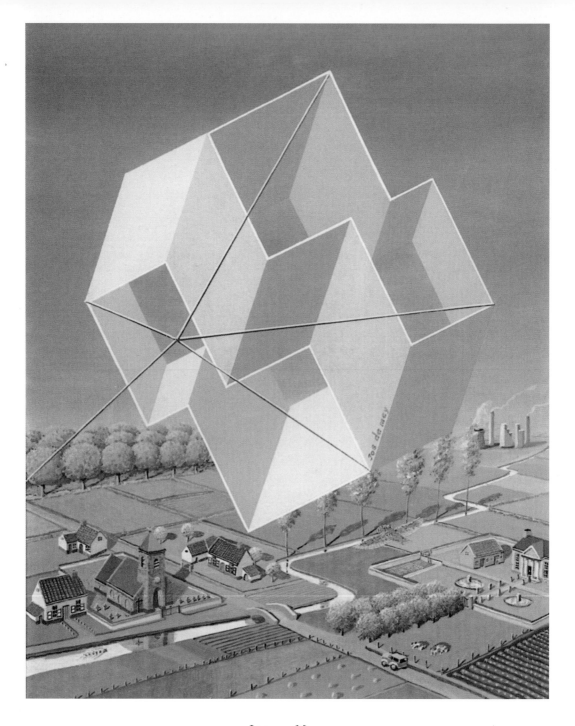

JOS DE MEY

UFO Over Flanders Country, 2005

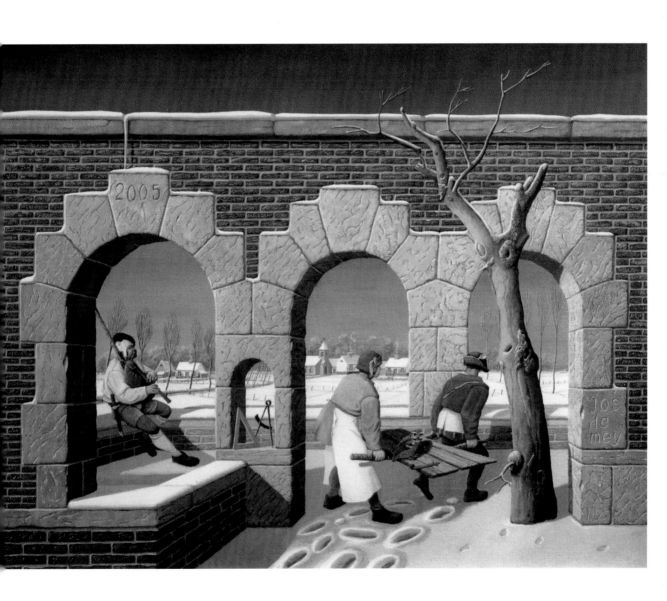

JOS DE MEY

Uilendragers, onder Muzikale Begeleiding, op weg Naar Utopia, 2005
Owl Carriers, with Musical Accompaniment, on the Road to Utopia, 2005

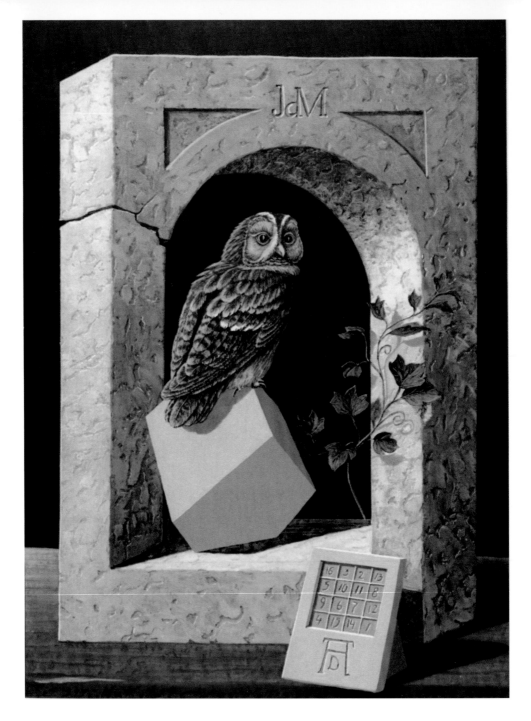

JOS DE MEY

Ontmoeting tussen De Steen van de Wijze Dürer en De Uil van JdM, 1997
Meeting between The Stone of the Wise Owl and JDM, 1997

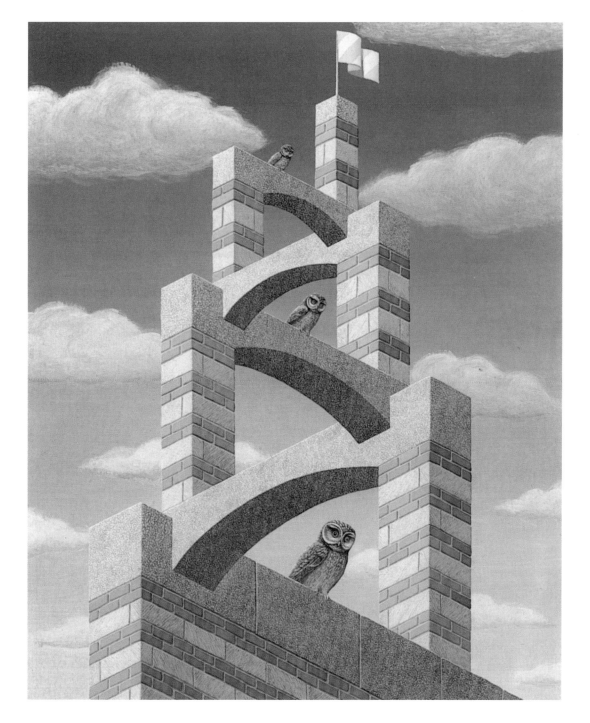

JOS DE MEY

De Ijle Toren van de Uilenburcht, 1987
The Thin Owls Castle Tower, 1987
Three owls perch on a tower that could only be possible in your imagination.

GALLERY | **39**

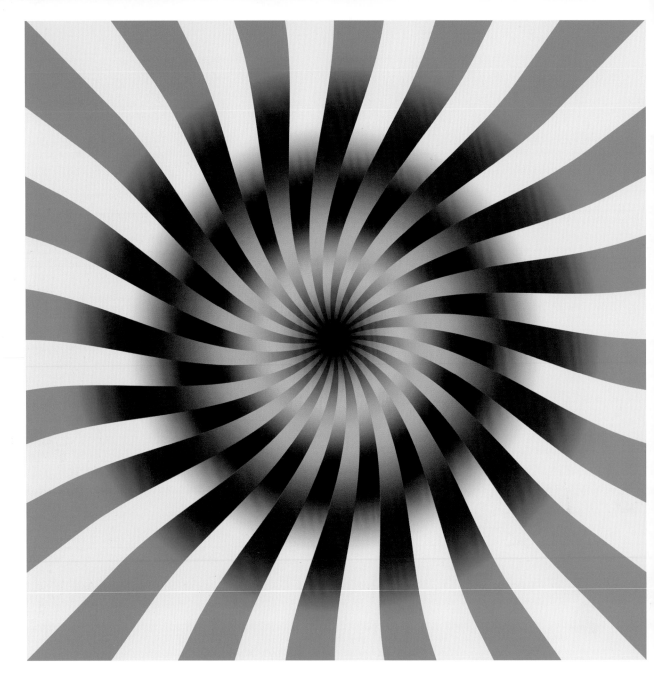

D. Alan Stubbs & Simone Gori

Breathing Light and Rotating Tilted Lines Illusion, 2007
Fixate on the center of the image and move your head quickly toward the page and then away from it. As you do, the center portion of the image will appear to get larger and smaller while the curved lines rotate. This figure is a complex variation of the Breathing Light/Dynamic-Gradient Illusion (Gori & Stubbs, 2006) and the Rotating Tilted Lines Illusion (Gori & Hamburger, 2006).

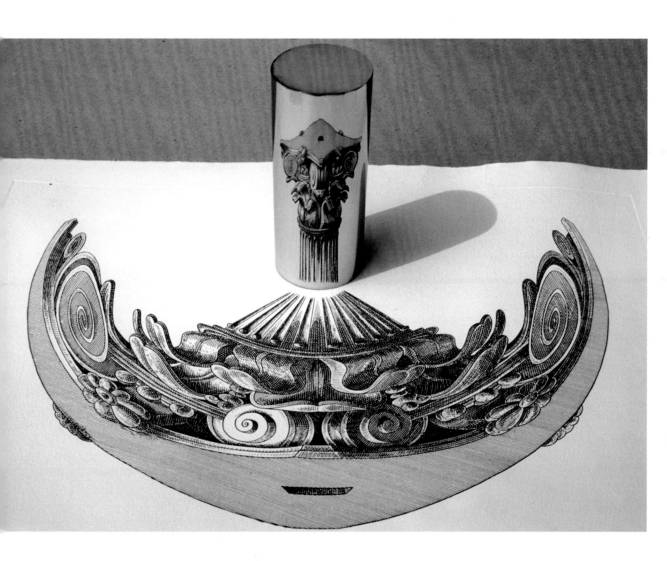

ISTVÁN OROSZ

Column Anamorphosis, 1994
By placing a cylindrical mirror on this drawing, a flat, distorted image is
transformed into a three-dimensional picture of a column.

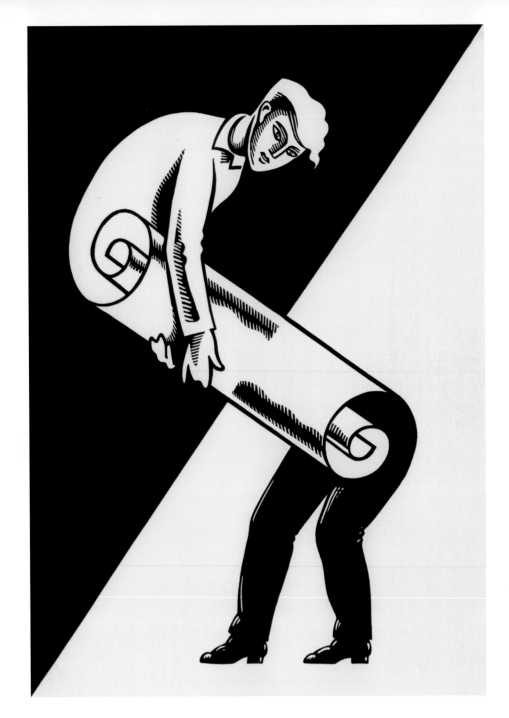

ISTVÁN OROSZ

Poster Gallery, 1995

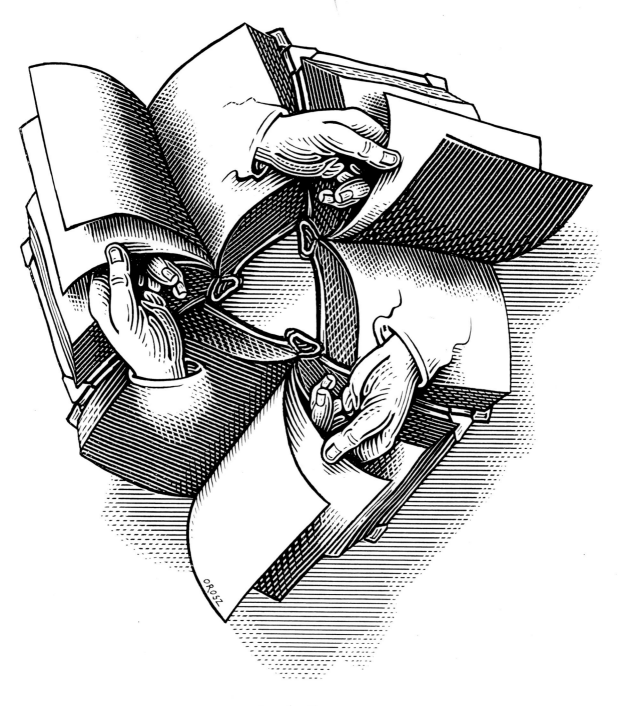

ISTVÁN OROSZ

Books, 1997

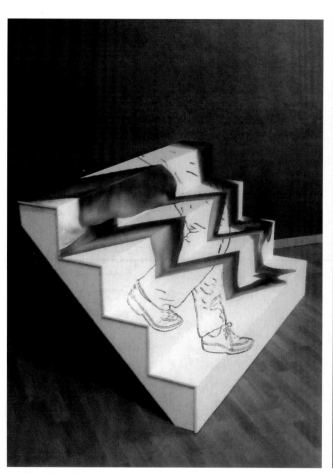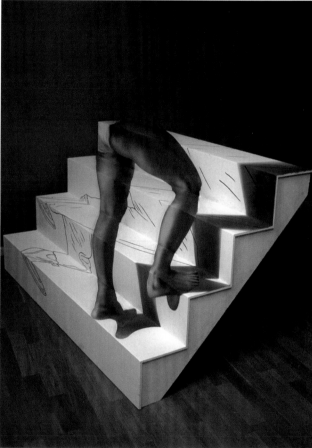

ISTVÁN OROSZ

Stairs, 1992

These painted stairs reveal two different sets of legs going up and down the stairs when viewed from different angles.

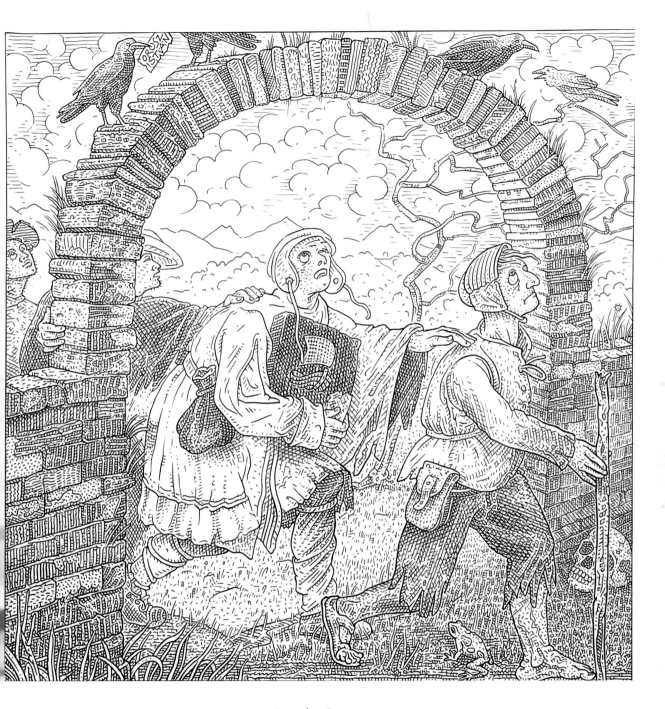

ISTVÁN OROSZ

The Ship of Fools XL, 2006
Do you see several people walking through an archway or something more sinister?

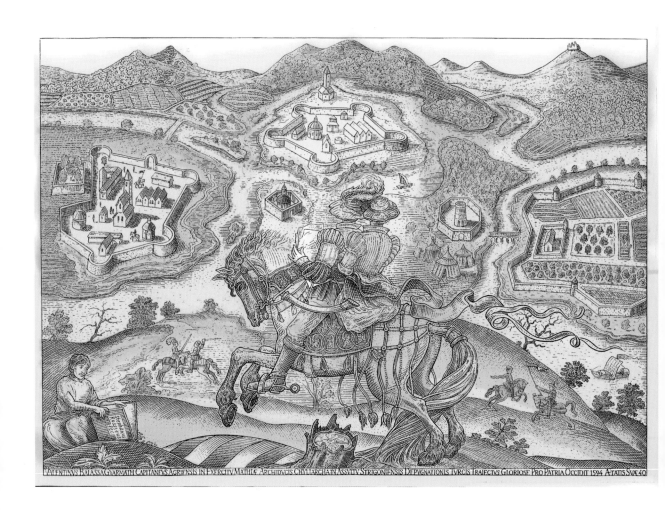

ISTVÁN OROSZ

Balint Balassi, 2004
A face is hidden in this drawing. Can you find it?

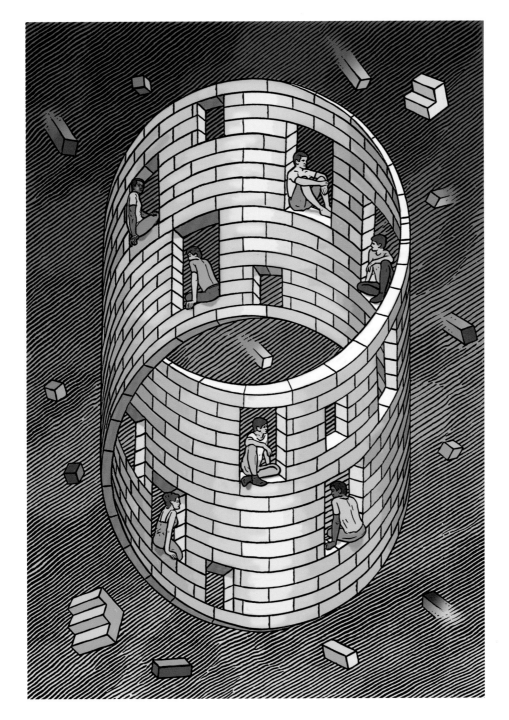

ISTVÁN OROSZ

The Round Tower, 1997
This tower, a twisted cylinder made of bricks, could not exist in reality.

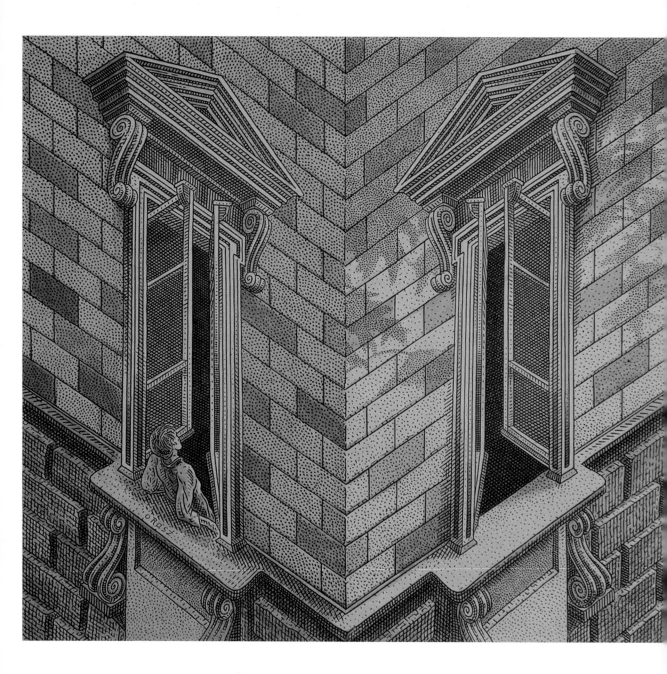

ISTVÁN OROSZ

Corner House, 1993

These two windows are on different sides of a house, yet they also appear to be facing each other at the same time.

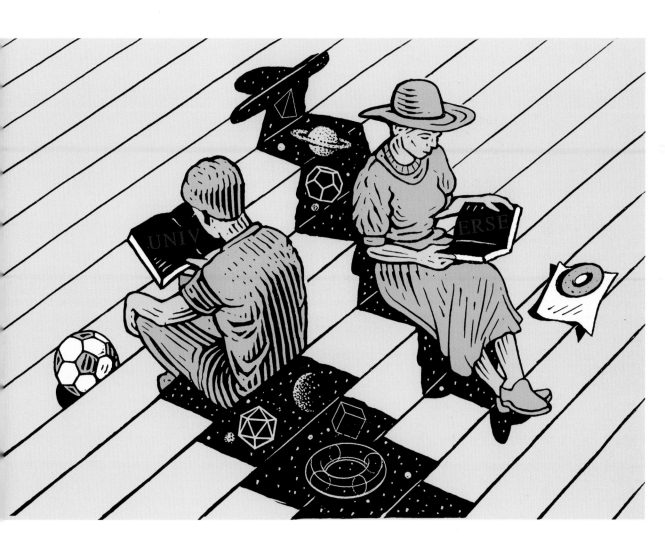

ISTVÁN OROSZ

Universe, 2002

How is it possible that this man and woman can sit back-to-back like this on the same set of steps?

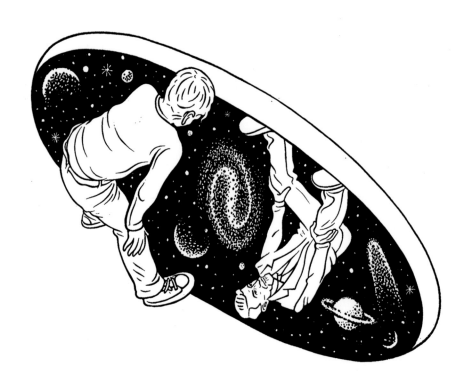

ISTVÁN OROSZ

Logo From Escher Museum Exhibition (The Hague), 2004

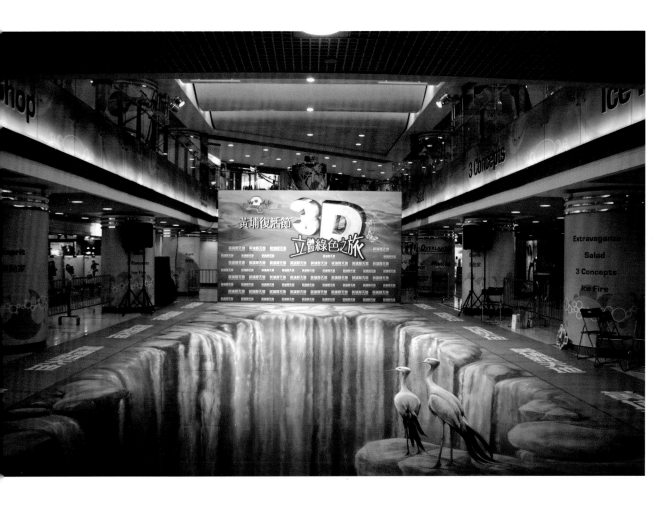

MANFRED STADER

Whampoa World (Hong Kong), 2010
This painting in Hong Kong transforms the flat surface of a floor into a stunning 3D indoor
waterfall, blurring the boundaries of reality and the imaginary.

MANFRED STADER

Dart Board, 2008
This 3D dart board drawing was completed on a completely flat surface for the
World Championship of Darts at Alexandra Palace in London.

JOHN LANGDON

Chain Reaction, 1991

This design presents a series of interconnected "chain reactions" that intersect at the letter O of the word REACTION.

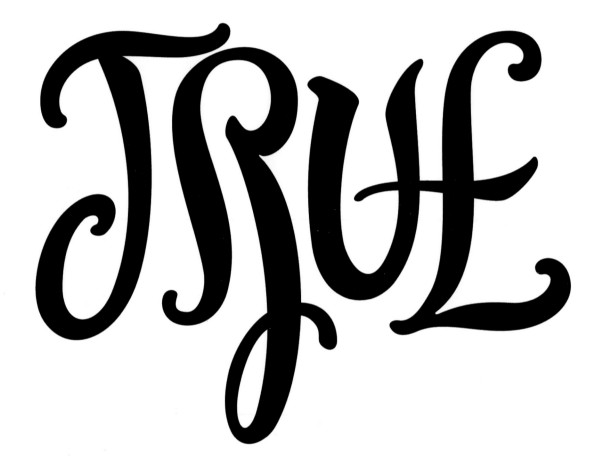

JOHN LANGDON

True/False, 1988

This ambigram features two words with opposite meanings that can be seen by rotating the page 180 degrees.

54 | GALLERY

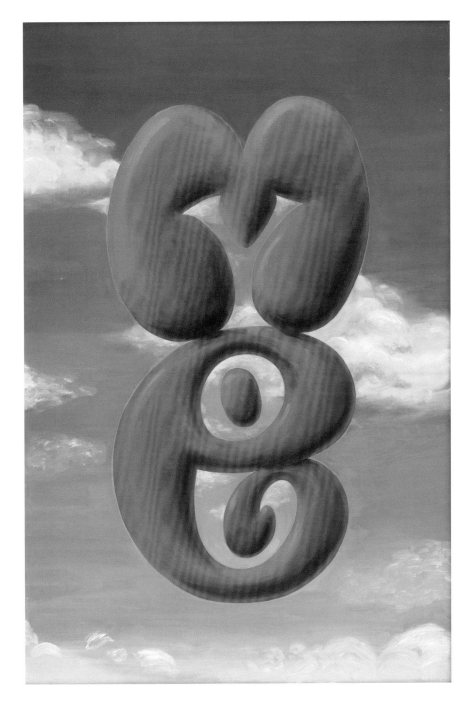

JOHN LANGDON

Us, 1996

This figure/ground ambigram features the word YOU embedded within the word ME.

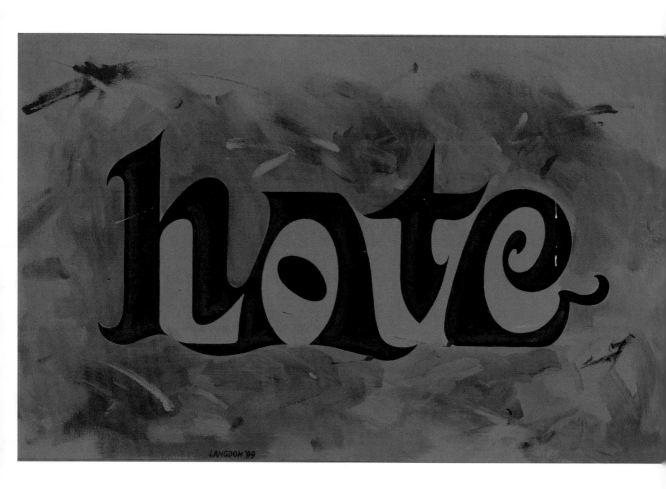

JOHN LANGDON

Love, 1999
Love and hate coexist in this figure/ground ambigram.

JOHN LANGDON

Optical Illusion, 1999
The words OPTICAL and ILLUSION are presented within the same space in this classic figure/ground ambigram.

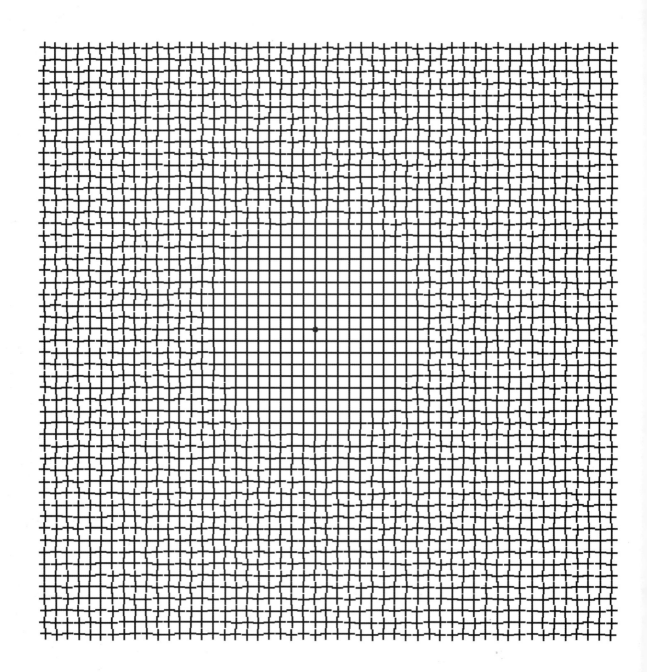

RYOTA KANAI

Healing Grid, 2005
Stare at the red dot in the center of this grid. Soon, the grid will begin
to heal itself and the distortions present will disappear.

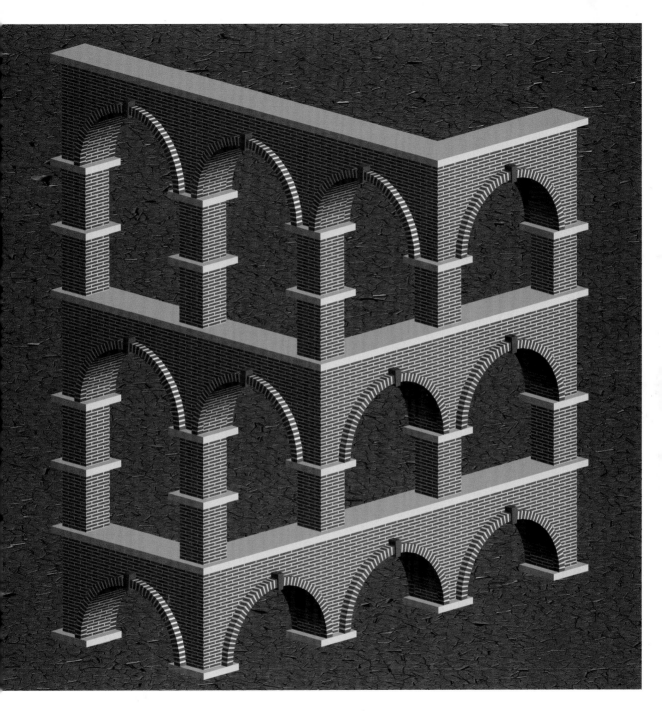

CATHERINE PALMER

Aqueduct, 2004
Something went terribly wrong in the construction of this aqueduct.

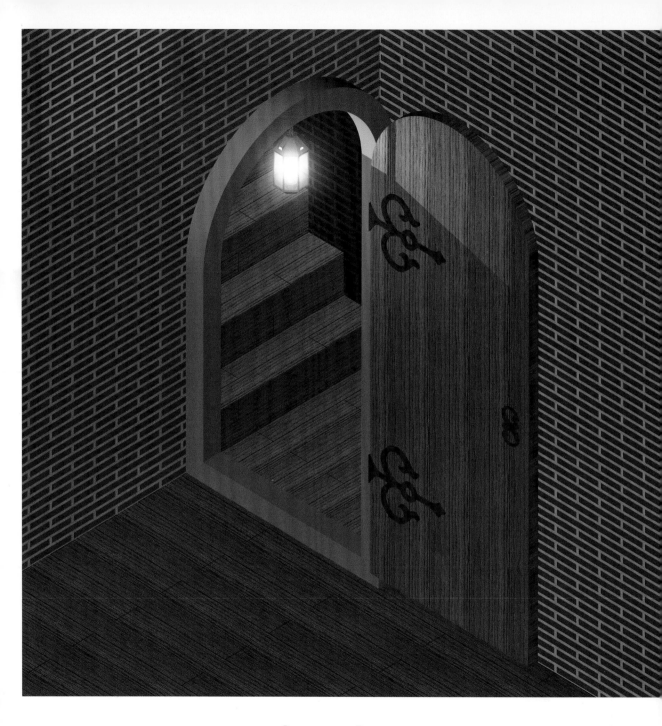

CATHERINE PALMER

Attic Door, 2004
Does this door look like it would be difficult to close?

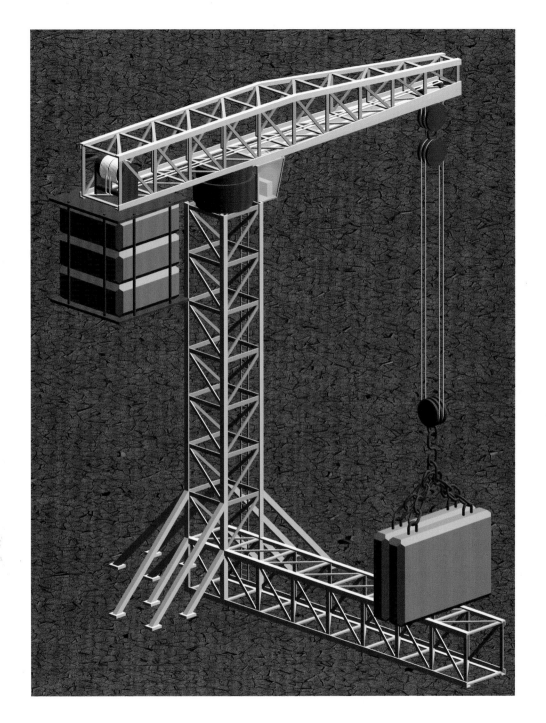

CATHERINE PALMER

Crane, 2010
Can you figure out what is wrong with this crane?

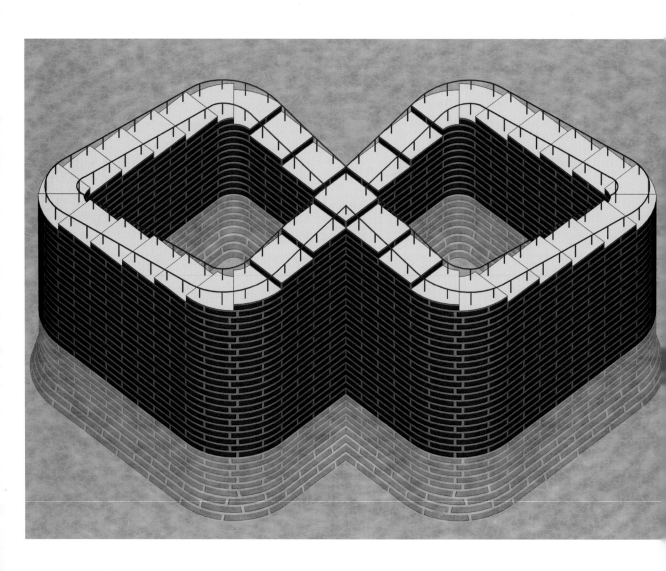

CATHERINE PALMER

Infinity Staircase, 2006
This continuous loops of impossible stairs appear to perpetually ascend or descend, depending on which way you walk.

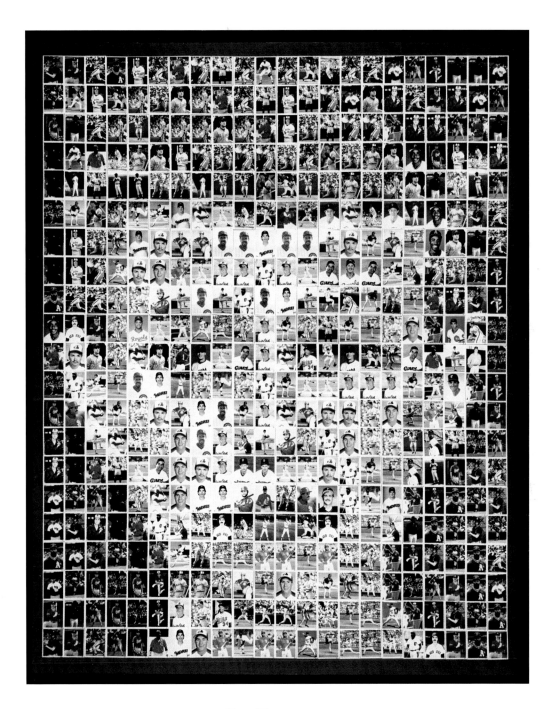

KEN KNOWLTON

Nicholas Jensen (Little League Pitcher), 2002
The baseball cards are arranged in such a way that the portrait of a young boy can be seen.

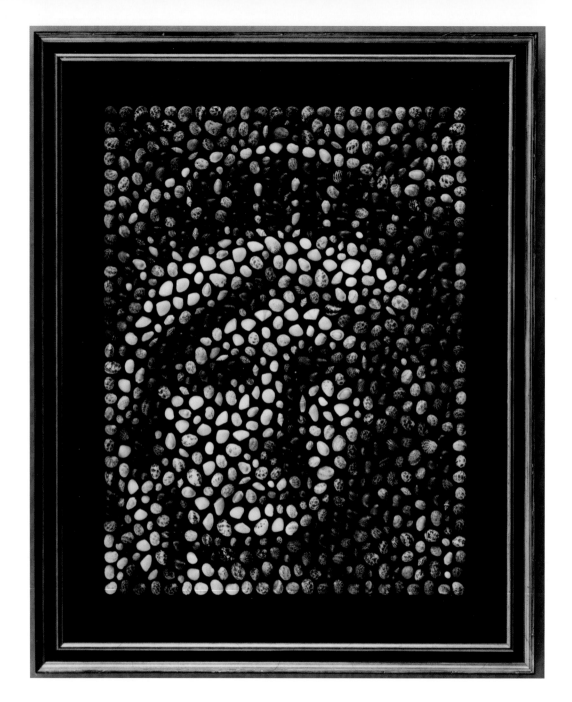

KEN KNOWLTON

Statue of Liberty, 1995
These seashells have been arranged in such a way that the Statue of Liberty can be seen.

KEN KNOWLTON

Barack Obama, 2009

Using a special computer-set font, a portrait of Barack Obama was generated
using actual words from his 2008 acceptance speech.

KEN KNOWLTON

Albert Einstein, 2001
Albert Einstein's face can be seen in this computer print made entirely of symbols from his famous equation.

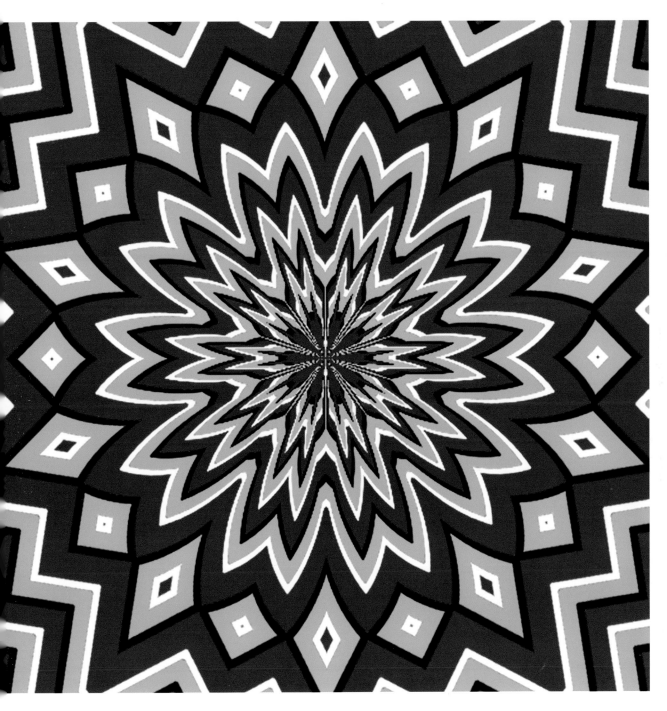

WALTER ANTHONY

Sea Sickness, 2007
Move your eyes around this image and it will appear to pulsate.

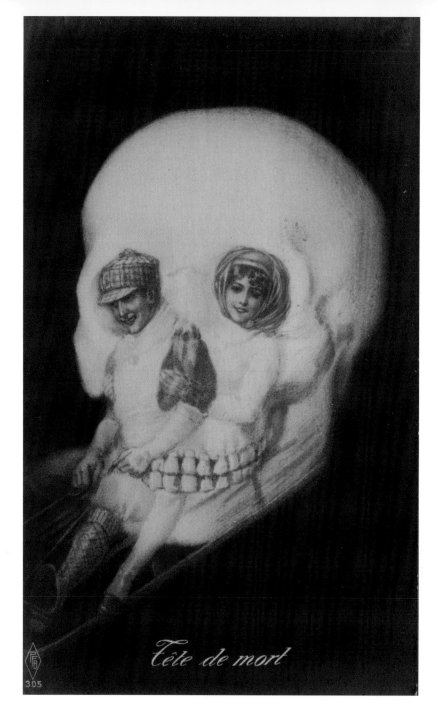

Tête de mort

UNKNOWN

Vintage Skull Illusion, circa 1900

This vintage double-meaning illusion shows either a man and woman enjoying themselves or the portrait of a skull. Which do you see?

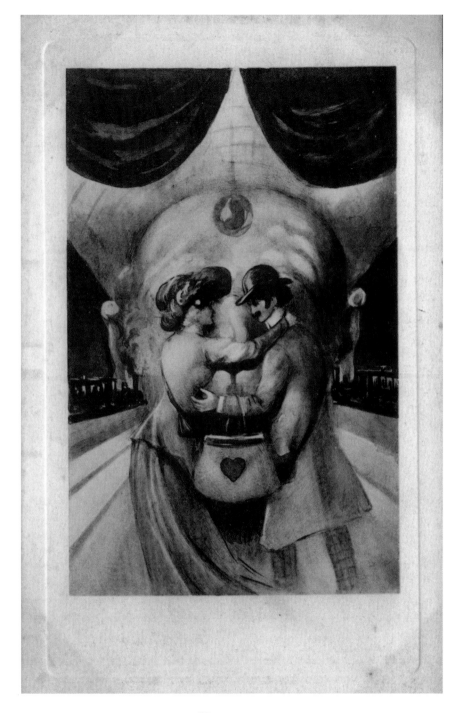

UNKNOWN

Metamorphic Postcard, circa 1900
A man and a woman dancing together reveal a hidden face. Can you find both?

UNKNOWN

Perceived Cube

A nonexistent white cube appears to exist even though it has not been drawn.

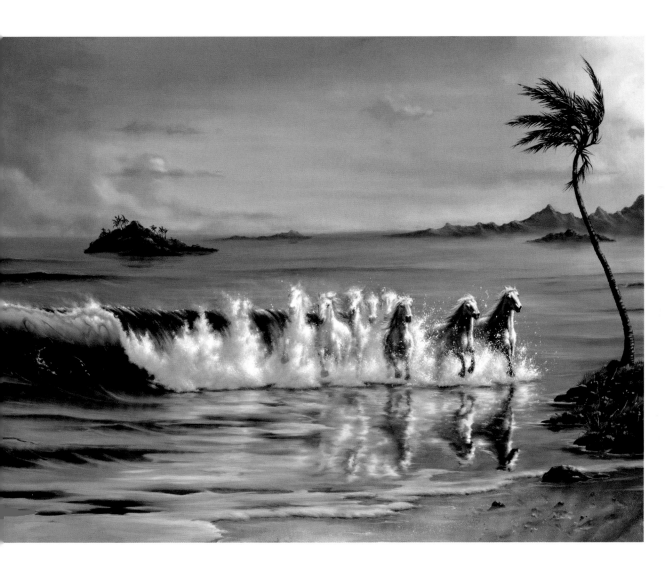

JIM WARREN

Galloping Waves, 2004
A breaking wave slowly morphs into galloping horses. This painting is from the
middle part of Jim Warren's Triptych "Dreamscape" series.

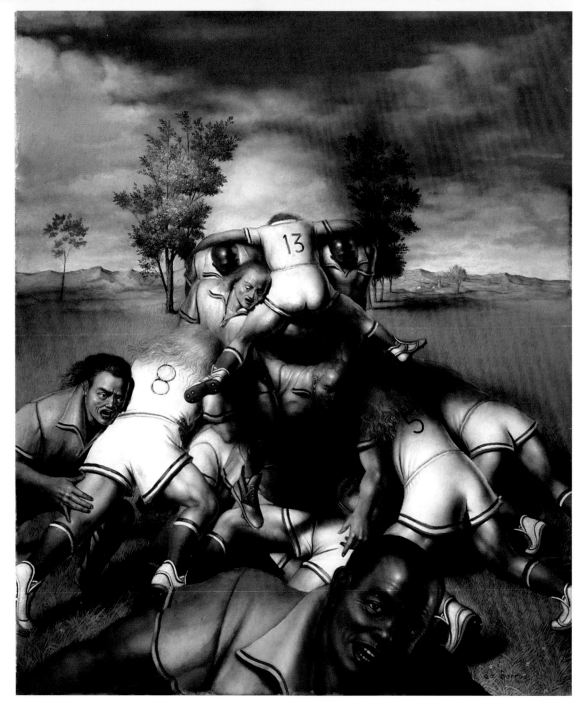

ANDRÉ MARTINS DE BARROS

La mélée, 1999/The Melee, 1999
A face hides among the rugby players in this scrum.

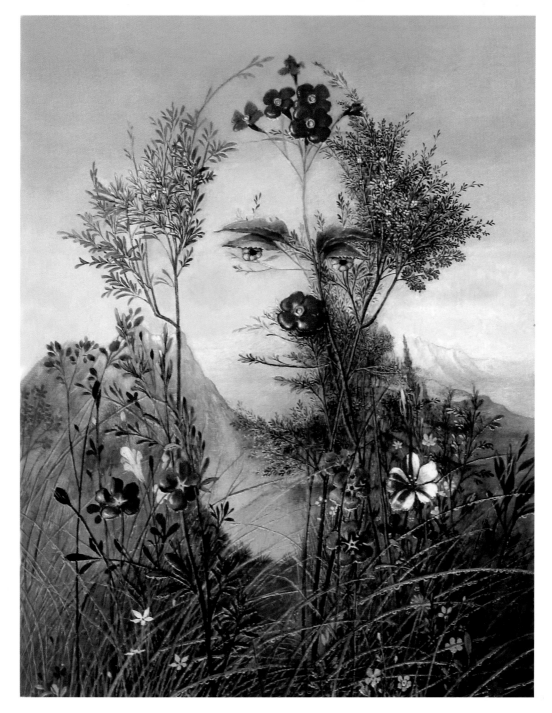

ANDRÉ MARTINS DE BARROS

Le clown champêtre, 1995/The Country Clown, 1995
A clown is hiding in the flowers among this landscape. Can you find him?

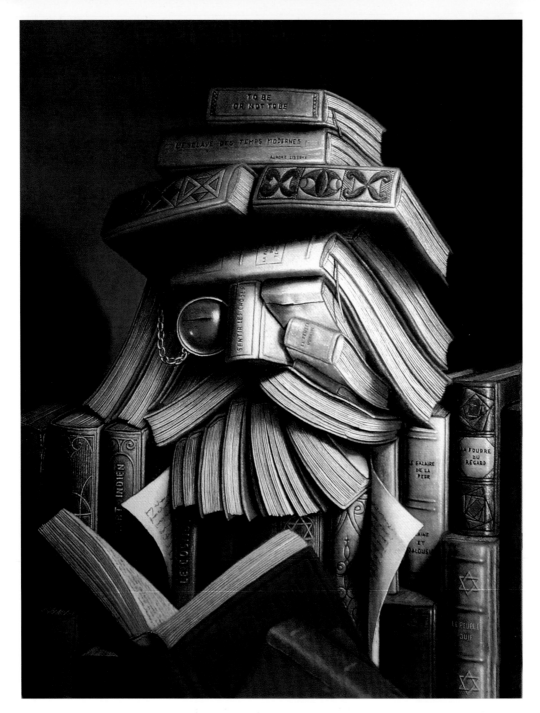

ANDRÉ MARTINS DE BARROS

Le libraire, 2004/The Bookseller, 2004
A collection of books arranged in a clever way comes to life in the form
of a bookseller who resembles the wares he peddles.

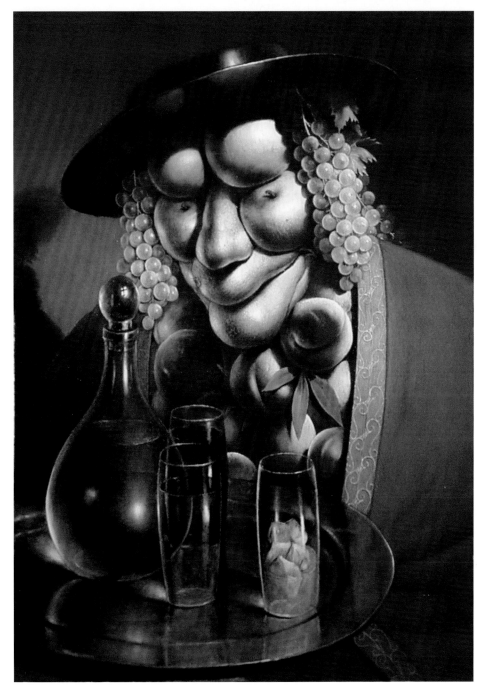

ANDRÉ MARTINS DE BARROS

Le serveur, 1994/The Server, 1994

STANFORD SLUTSKY

Parallelogram, 2006

Two cubes can be seen in this figure. Does the diamond pattern in the center
belong to the cube on the left or the cube on the right?

STANFORD SLUTSKY

Suspended, 2005
Depending on how you perceive this image, you will either see a large cube or a smaller cube floating in the center.

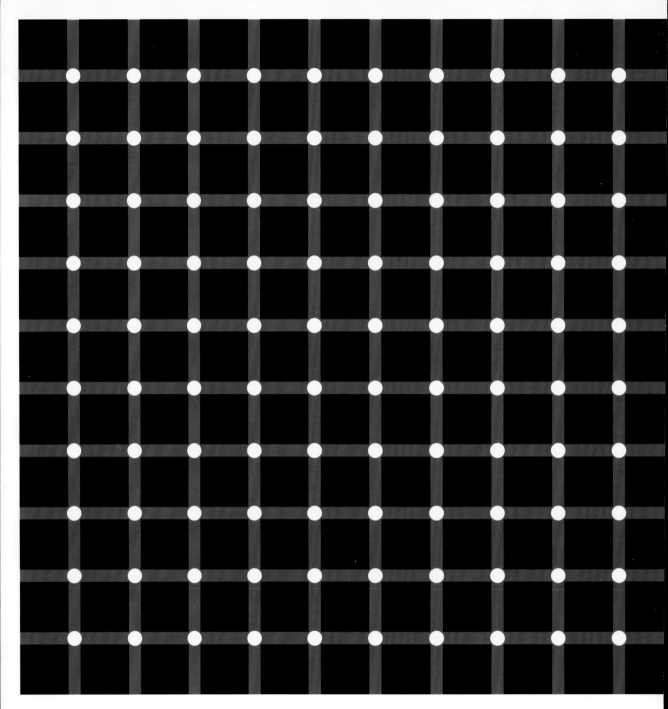

M. SCHRAUF, B. LINGELBACH, AND E.R. WIST

Scintillating Grid Illusion, 1997
Try to count the number of black dots.

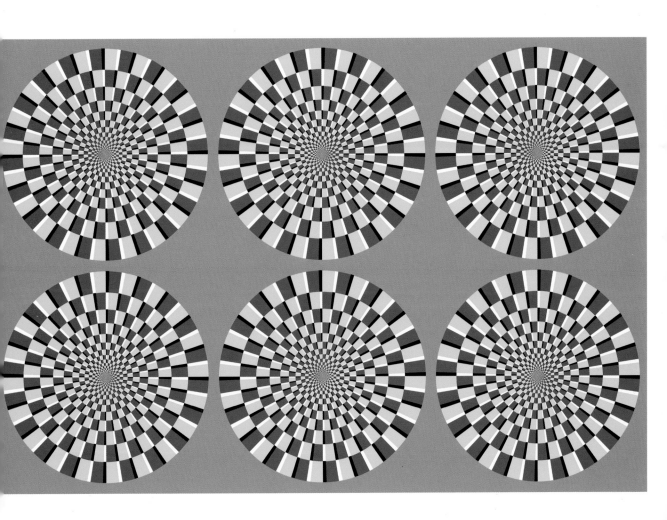

AKIYOSHI KITAOKA

Optimized Fraser-Wilcox Illusion, Type IIa, 2007 & 2008
The circles appear to rotate spontaneously in this peripheral drift illusion.

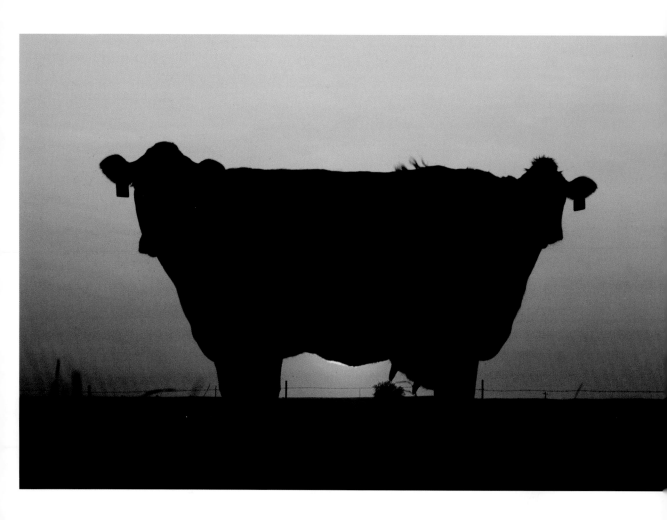

JERRY DOWNS

Both Sides Cow, 2007
What is going on here? This shot of one cow standing behind the other was taken at sunset in Idaho.

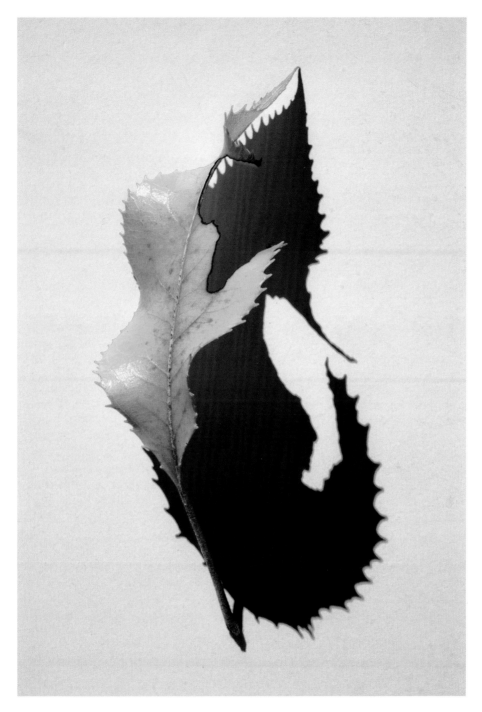

JERRY DOWNS

See Horse, 2011
See the seahorse in the shadow of the leaf?

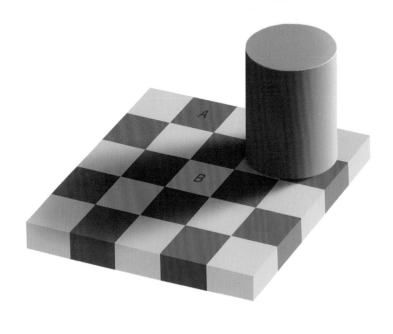

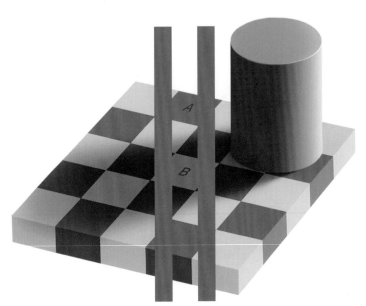

EDWARD ADELSON

Checker Shadow Illusion, 1995

The squares marked A and B are the same shade of gray. By adding two vertical gray stripes to the image, it becomes obvious that this is true.

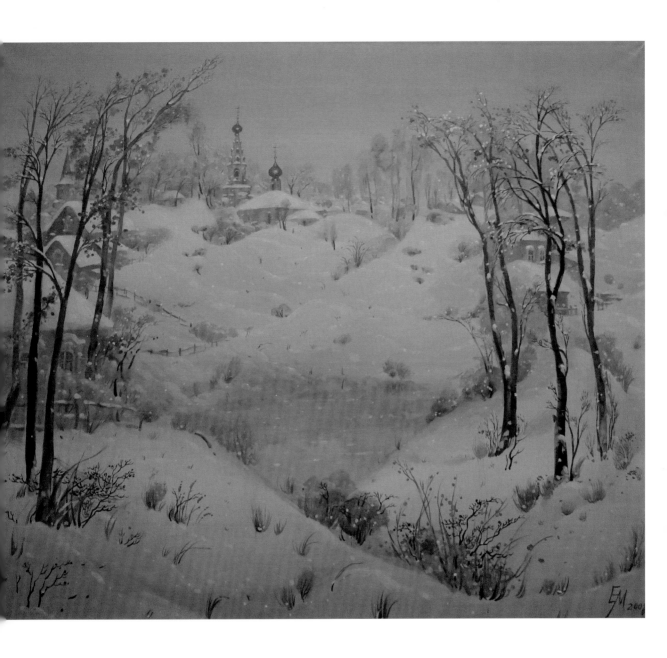

ELENA MOSKALEVA

A Happy Day in Province, 2008
A face of a boy and a girl are hidden in this landscape painting.

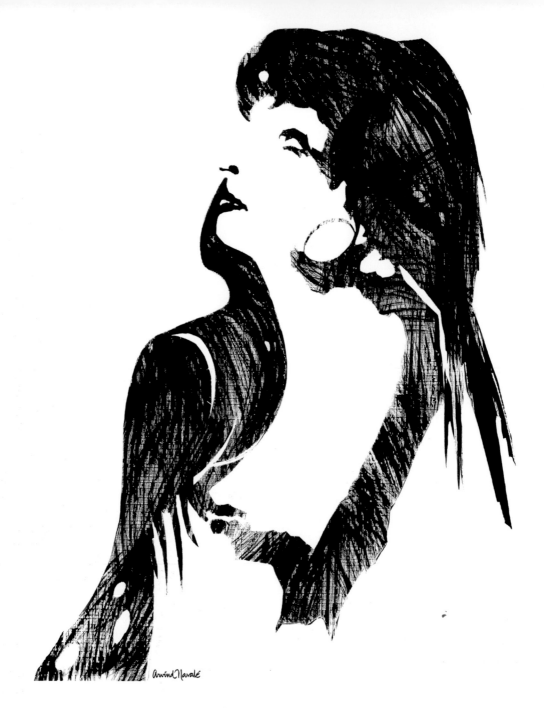

Arvind Narale

Peacock and a Parrot/Woman Looking Up, 2002
Do you see two birds or a woman looking toward the sky?
Can you find both in this ambiguous pencil sketch?

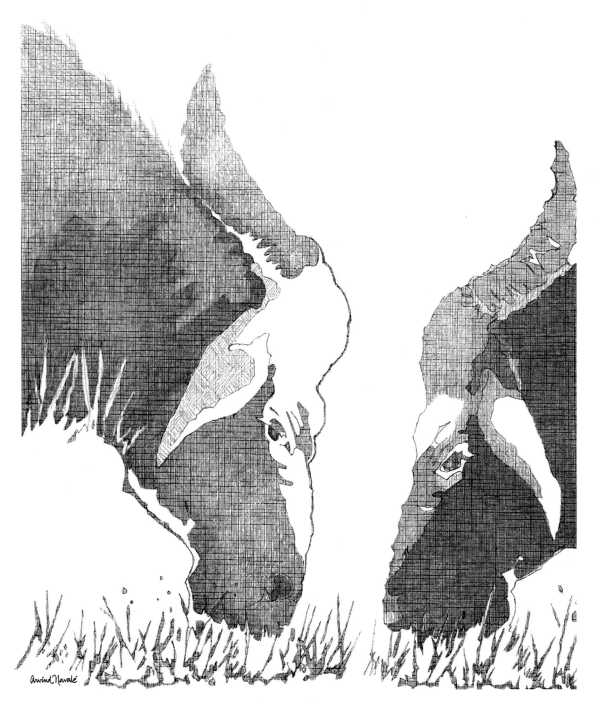

ARVIND NARALE

Two Indian Buffaloes/A Cow Grazing, 2003
Depending on how this pencil sketch is viewed, you will either see two buffaloes
facing one another or one grazing cow looking directly at you.

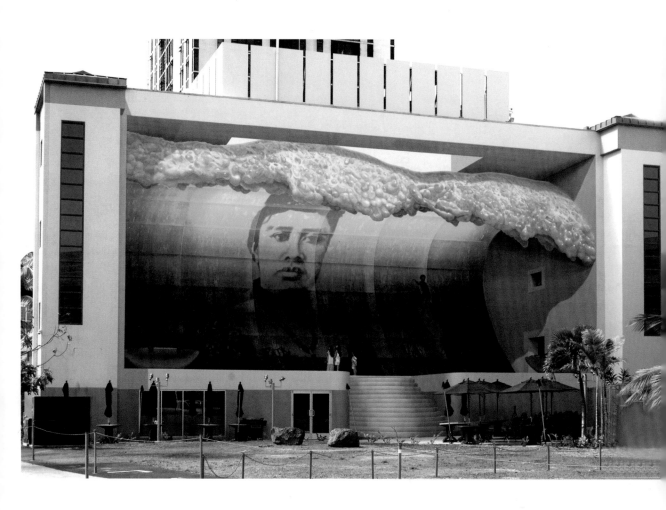

John Pugh

Mana Nalu Mural, 2008

This mural is located on the east side of the Lani Nalu Plaza building in Honolulu, Hawaii. This entire scene is painted on a flat wall. The stairs, children, and wave are all part of the illusion of depth.

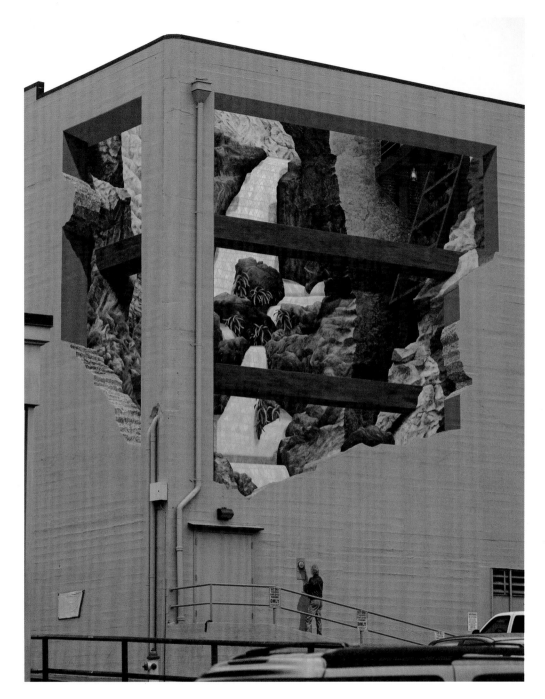

JOHN PUGH

Grass Valley Mural, 2009

From a distance, this mural appears as a dramatic opening in the Del Oro Theater in Grass Valley,
CA. When studied up close, the attention to detail is nothing short of breathtaking.

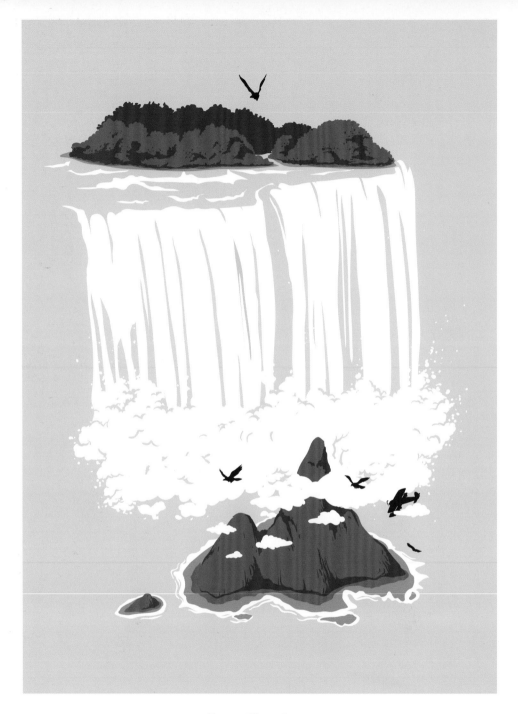

CHOW HON LAM

Falling Over, 2010
A waterfall or clouds? It all depends on your perspective.

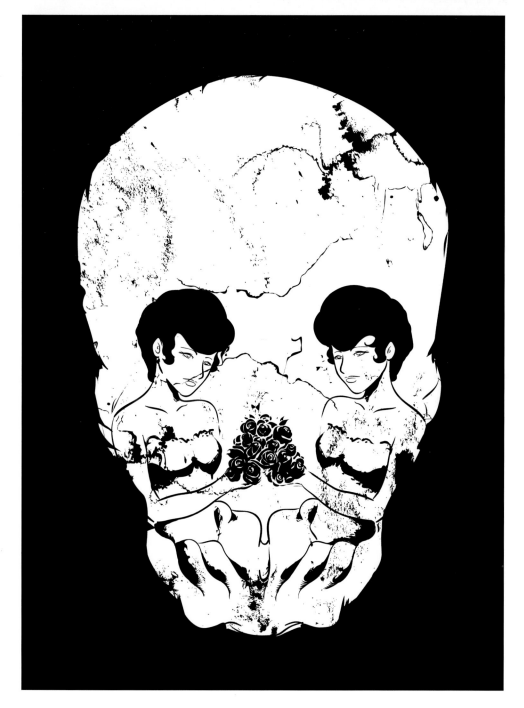

CHOW HON LAM

Dark Sister, 2010
Is this a picture of two girls holding flowers facing each other or something scarier?

CHOW HON LAM

Feng Shui Dragon, 2010
Can you find the dragon hidden in this mountain?

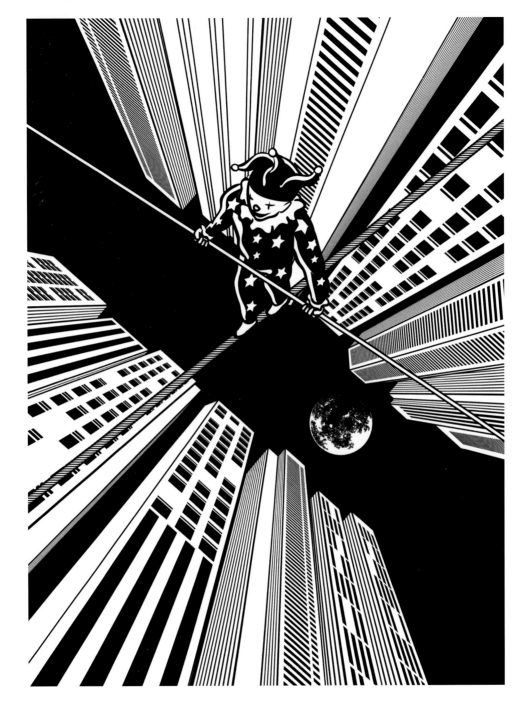

CHOW HON LAM

Midnight Walker, 2010
Is this tightrope walker walking upside down on this tightrope? The buildings and
placement of the moon underneath the walker give the impression that he may be.

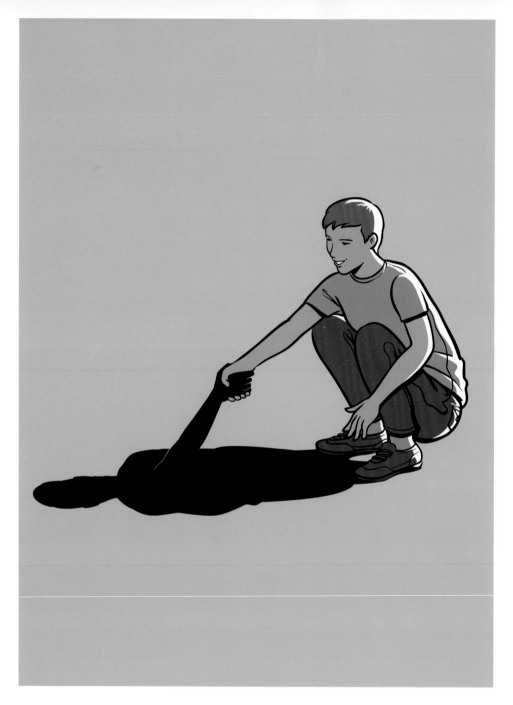

CHOW HON LAM

Nice To Meet You, 2010
A man and his shadow get to know one another.

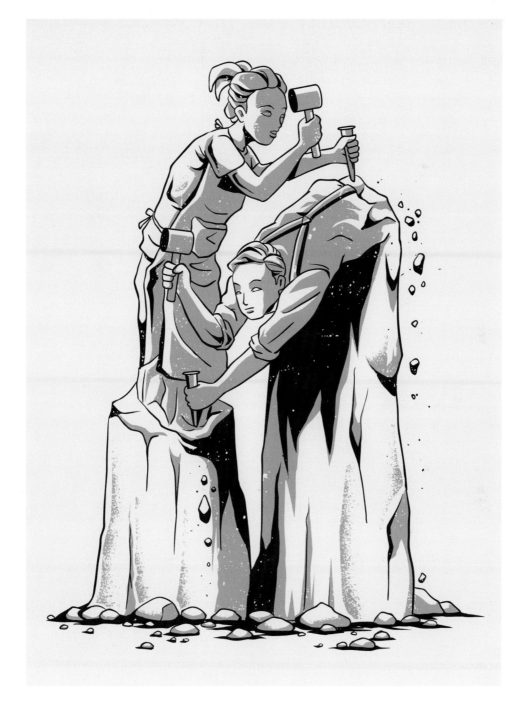

Chow Hon Lam

Statue Workers, 2010
A boy and a girl lend each other a hand as they chisel themselves into existence.

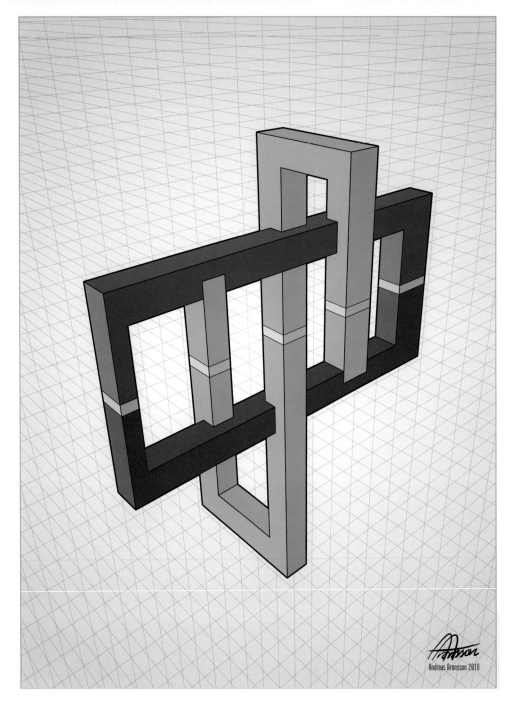

ANDREAS ARONSSON

Serpent, 2010
The flat blue and purple frame has a green snake that intersects it at several points,
this even while the snake is perpendicular to the frame.

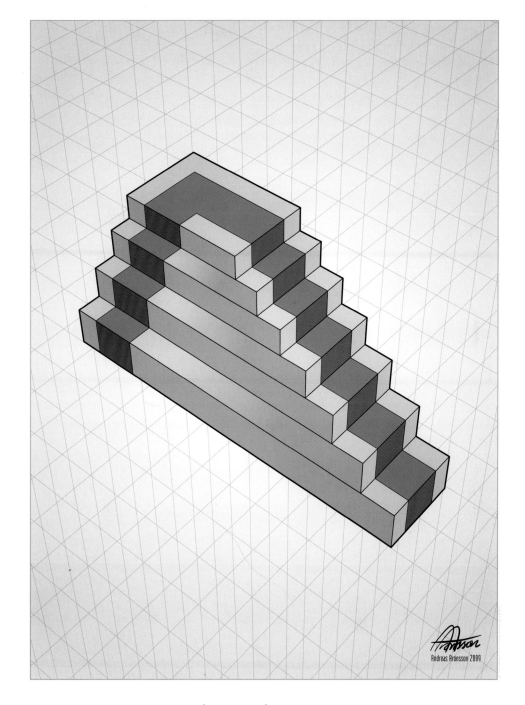

Stairs5, 2009

Depending on which side you access this pair of stairs, you get to climb a different number of steps.

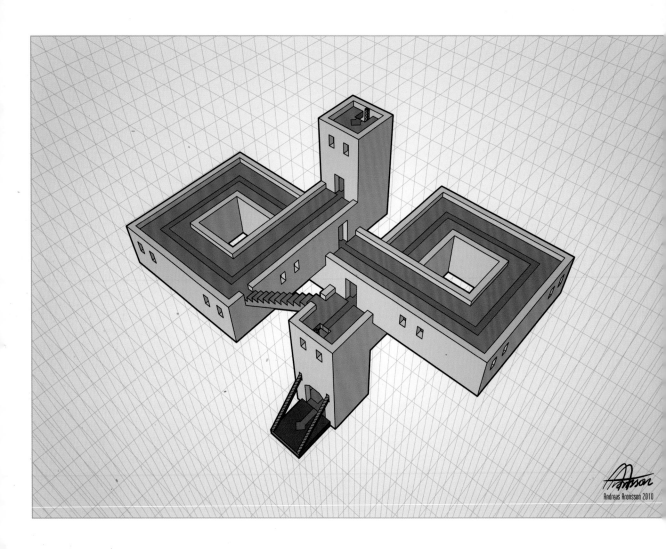

ANDREAS ARONSSON

Tower2, 2010

This tower is actually not very high, or is it? Even though the horizontal path is completely flat, it climbs up on itself, adding height. Even then you can climb down from the bottom of the path to the top.

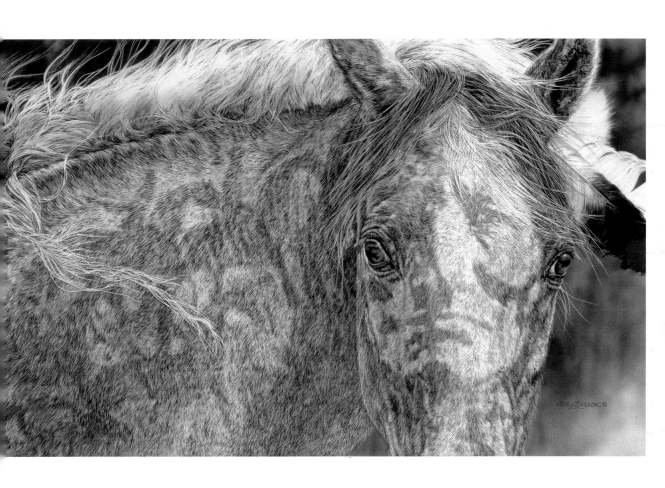

JUDY LARSON

Red Horse, 2011
Chief Red Horse is camouflaged in this painting by American artist Judy Larson. Do you see him?

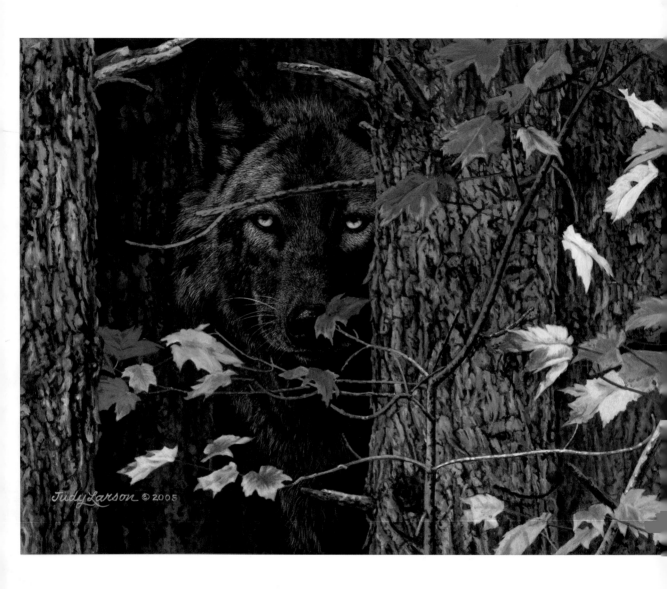

JUDY LARSON

Intent, 2011
Can you find the two wolf pups hiding in this painting of their mother?

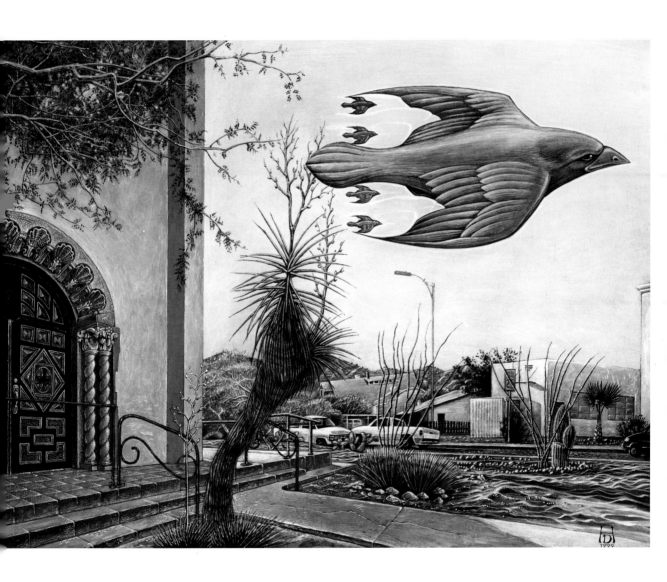

HOP DAVID

Seven Birds, 2002
At first glance, five birds are easily visible. Can you find the other two hidden birds?

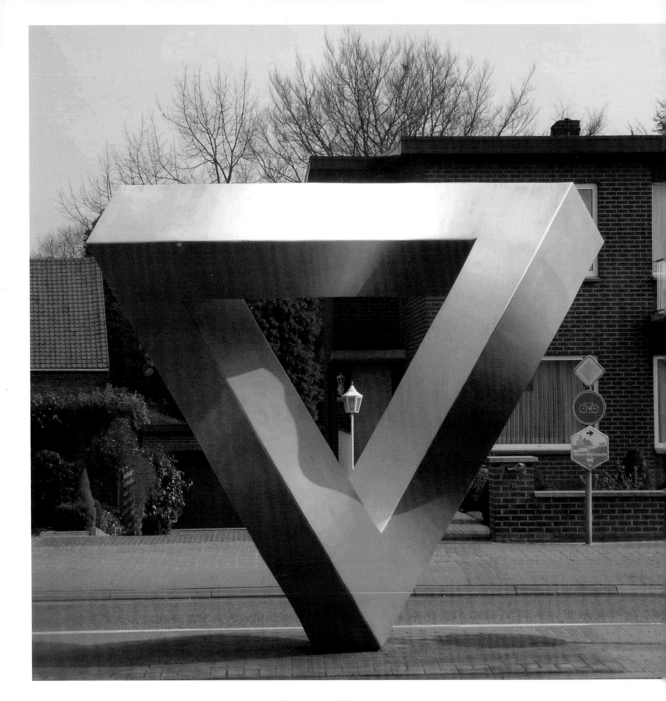

Mathieu Hamaekers

Unity, 1995

This impossible triangle sculpture, made of wood and finished with polyester, was erected in the center of the Belgian village of Ophoven. The facing page shows the same sculpture from a different angle to reveal how this illusion works.

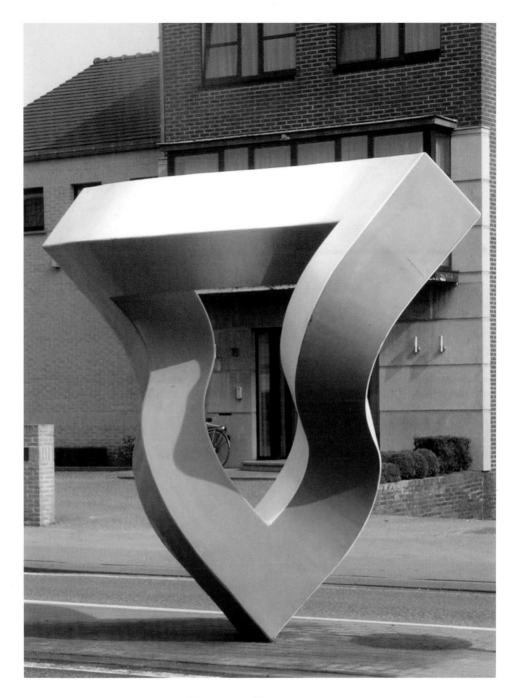

MATHIEU HAMAEKERS

Unity, 1995

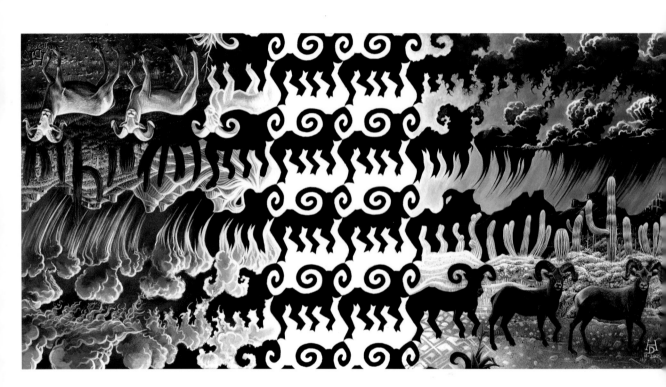

Hop David

Rams, 2005
The abstract tessellation in the center of this image morphs into a realistic desert scene when viewed both right side up and upside down.

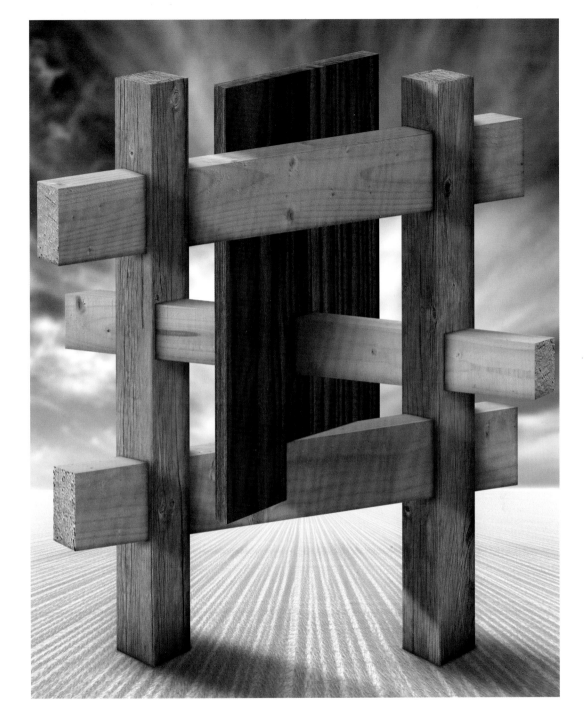

ROBIN REITHMAYR

Impossible Wood Construction, 2011
This wooden structure is not physically possible.

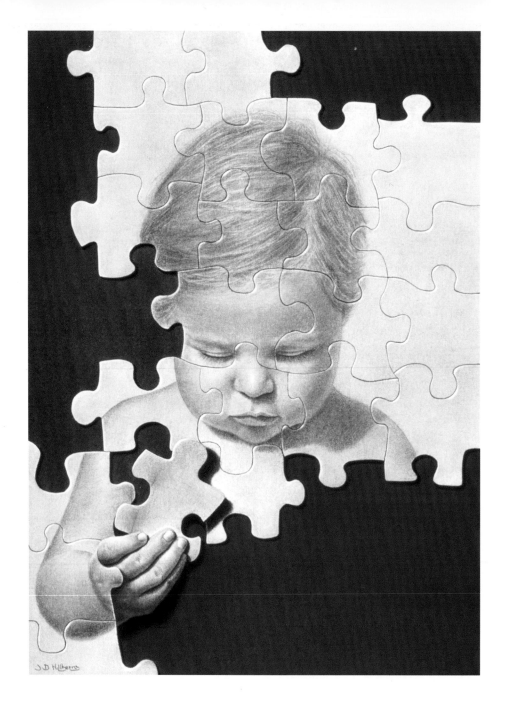

J.D. HILLBERRY

Putting it Together, 1995

This charcoal and graphite drawing on white paper depicts the artist's two-year-old son at the beginning stages of learning about himself and what the world has to offer.

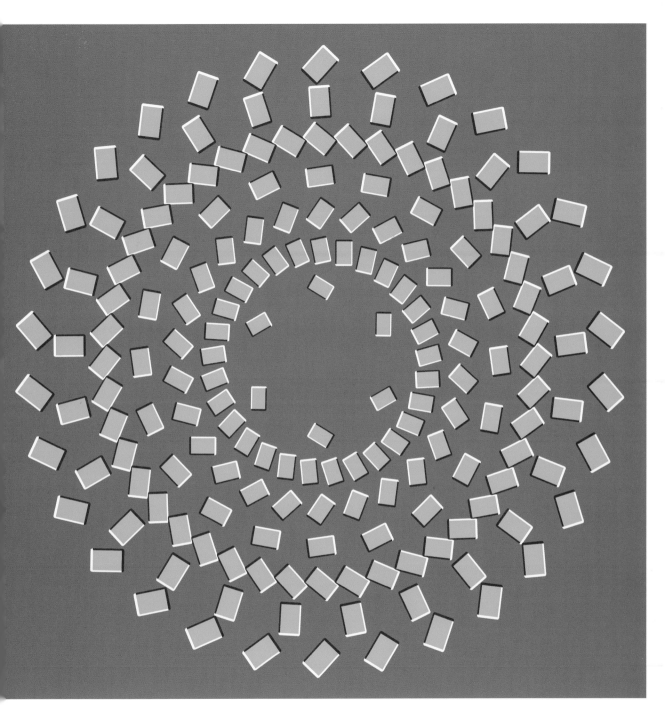

JAIME VIVES PIQUERES

Color Motion Illusion, 2006
As you move your eyes around this image, the green blocks appear to be in motion.

DAVID SWART

Pinky Dinky Dave Thinks Big, 2006
This photograph uses a trick, known as the Droste effect, to create a strange loop
involving increasingly smaller versions of the same picture.

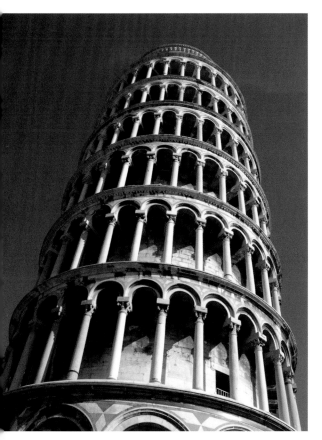
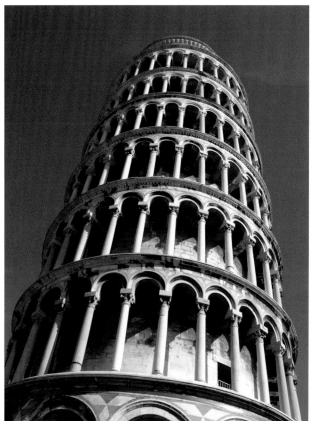

FRED KINGDOM

Leaning Tower Illusion, 2007
The tower on the right appears to be leaning more yet the two pictures are identical.
This illusion was a finalist in the 2007 Best Illusion of the Year Contest.

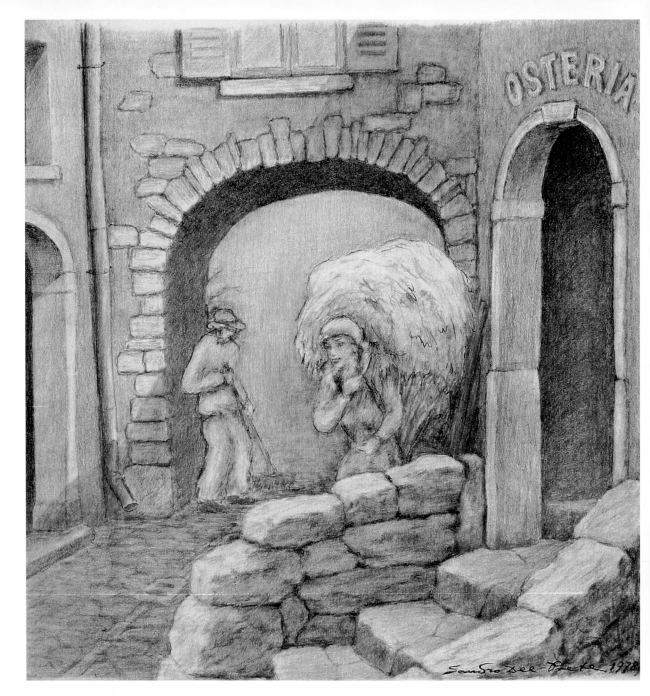

SANDRO DEL-PRETE

In a Ticino Village, 1978

Under the archway, a street sweeper is doing his job in a Ticino village. The woman walking in the alley is carrying a basket loaded with hay. The illustration also reveals the hidden profile of an elderly gentleman who could easily be the schoolmaster or the mayor of the community.

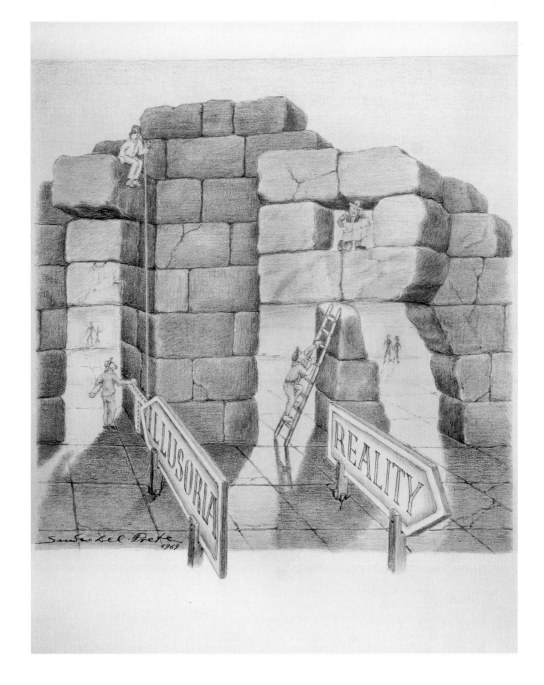

Between Illusoria and Reality, 1969
A huge wall has been erected out of giant, dilapidated stone blocks and serves as a physical border between two worlds. An illusionary building has been crafted out of heavy stone blocks that disappear in a whiff of smoke. This monument to the past seems to ask the eternal questions: What is illusion, and where does reality begin?

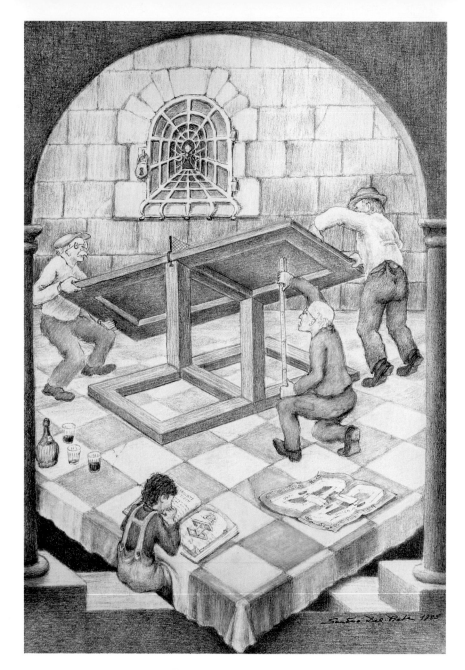

SANDRO DEL-PRETE

The Crazy Table, 1985

Three craftsmen try to assemble the elements of a prefabricated table by placing all pieces of identical length in parallel with each other, each in their corresponding notches. The angles and junctions match the plan perfectly. However, they are dumbfounded to see that the tabletop surface is angled and leaning to one side. Pushing and bending doesn't help, so they decide to exhibit the crazy table where it is to show that even useless things sometimes fit a useful purpose.

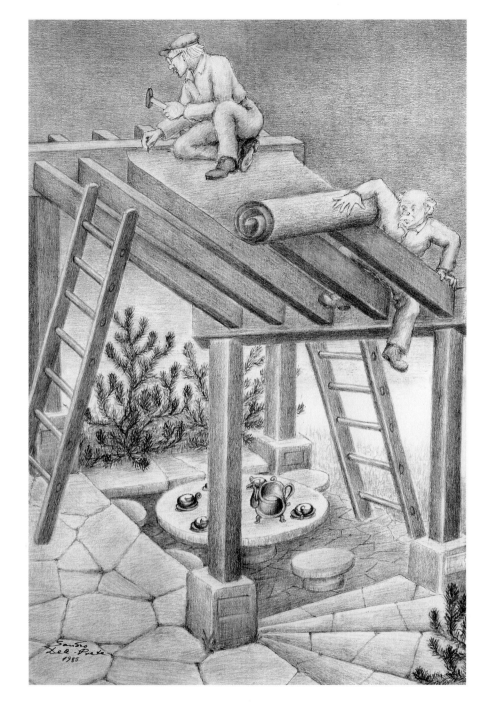

SANDRO DEL-PRETE

The Twisted Pergola, 1985
A rich man, an admirer of impossible things, wished to cover the pergola in his garden to have more shade, but due to the job's curious difficulties, the craftsmen had to overcome some very unusual problems.

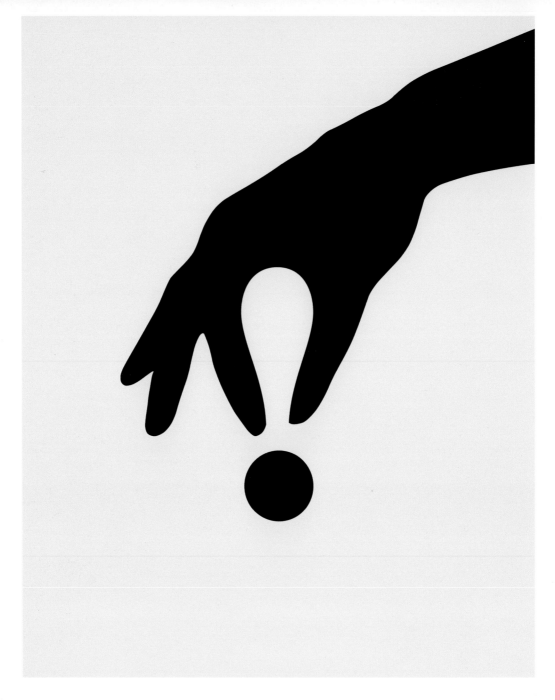

SIMON C. PAGE

Exclamation Mark, 2010
Graphic designer and illustrator Simon C. Page designed this as part of his "More Than Meets The Eye"
series. Do you see a finger and thumb reaching for a ball or an exclamation mark?

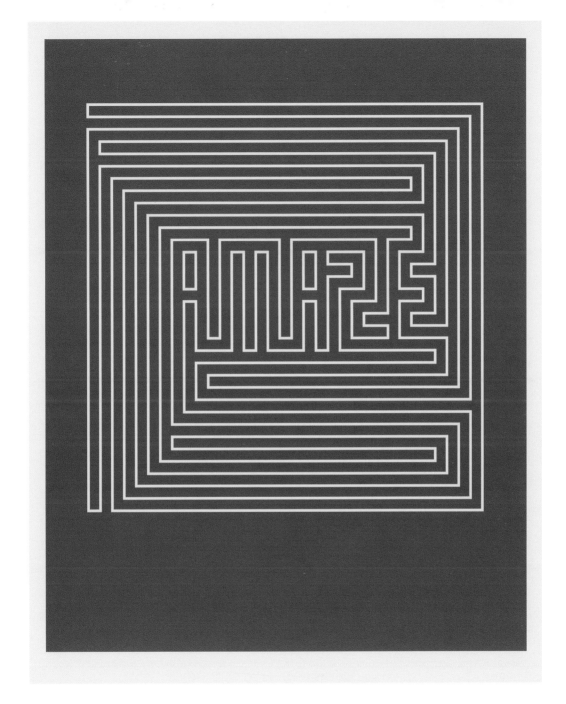

SIMON C PAGE

Amaze, 2009
There is something remarkable about this maze. Can you spot what makes it so amazing?

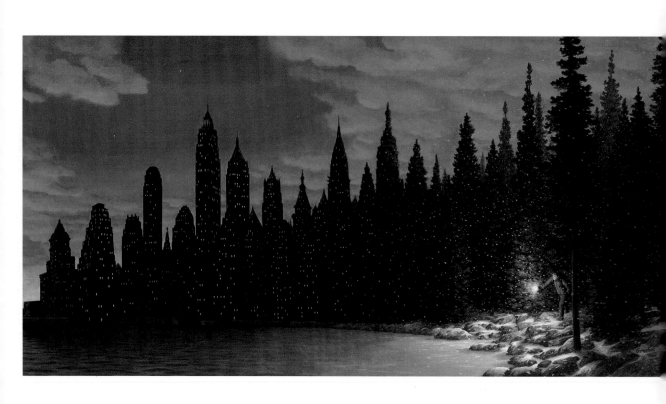

ROB GONSALVES

Light Flurries, 2010

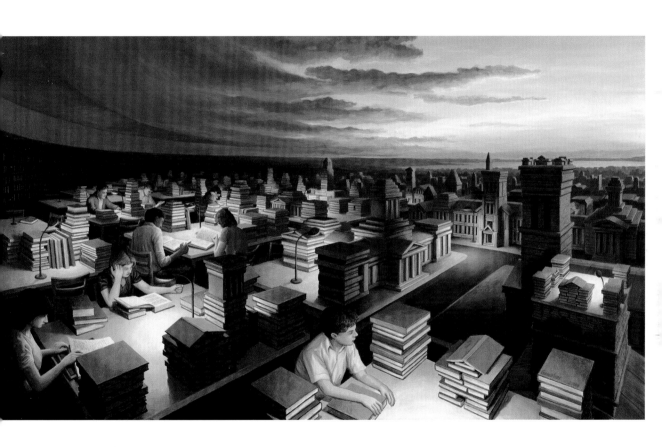

ROB GONSALVES

Towers of Knowledge, 2009

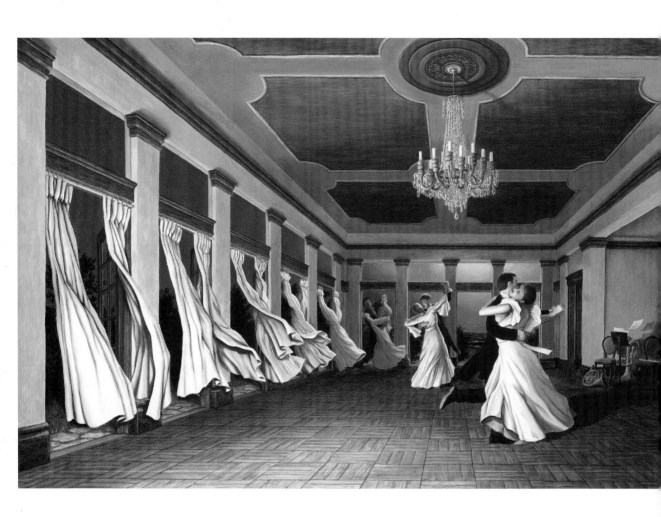

ROB GONSALVES

The Dancing Wind, 2007

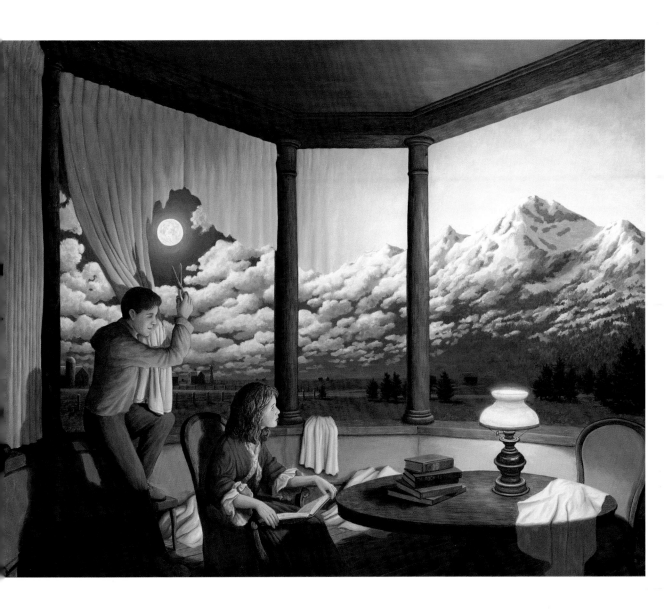

ROB GONSALVES

Change of Scenery II (Making Mountains), 2008

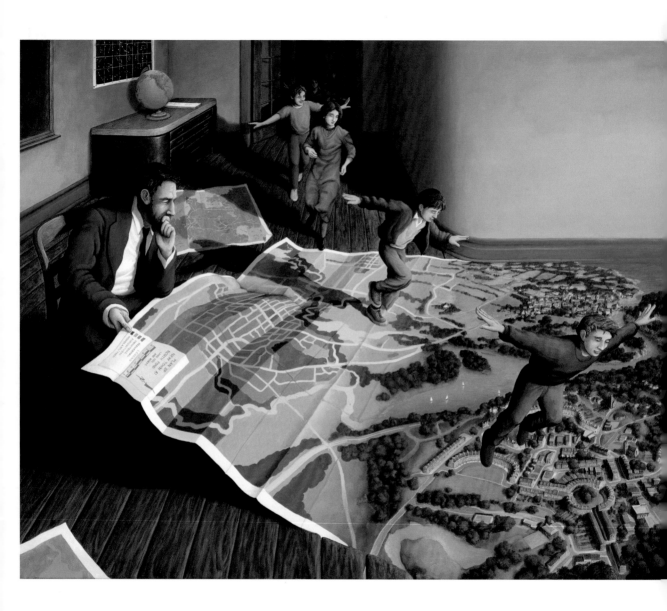

ROB GONSALVES

Flight Plan, 1996

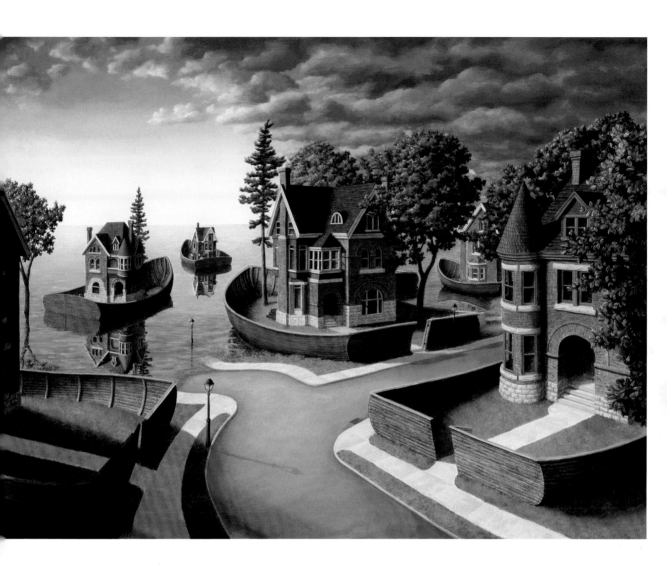

ROB GONSALVES

Flood Fences, 1996

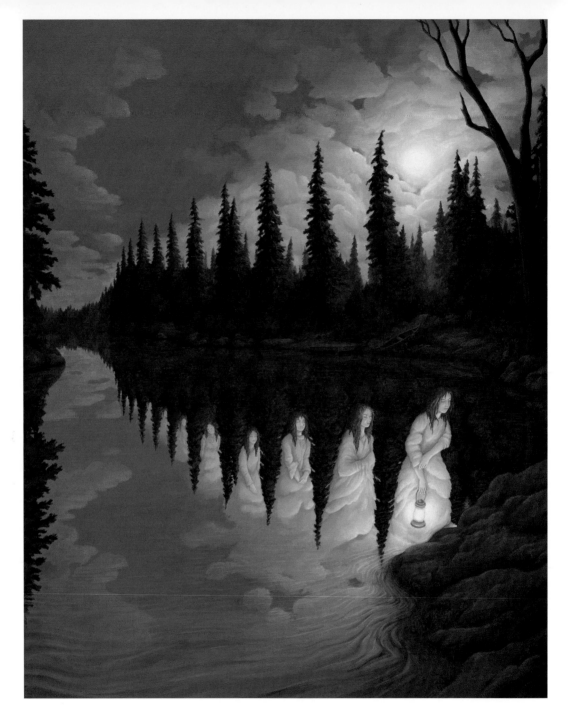

ROB GONSALVES

Ladies of the Lake, 1993

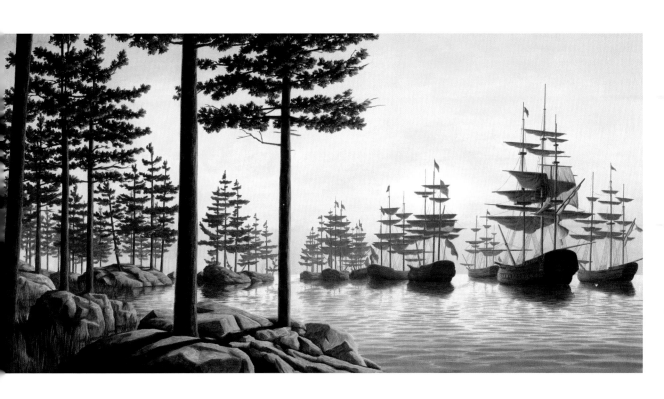

ROB GONSALVES

Sailing Island, 2009

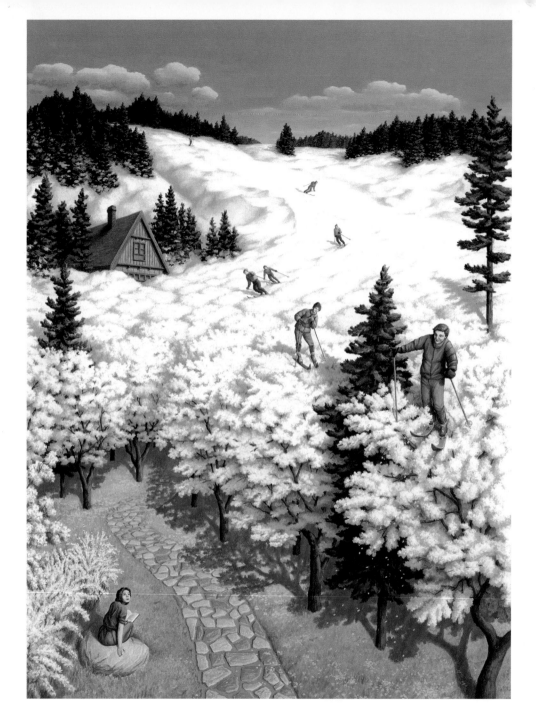

ROB GONSALVES

Spring Skiing, 2000

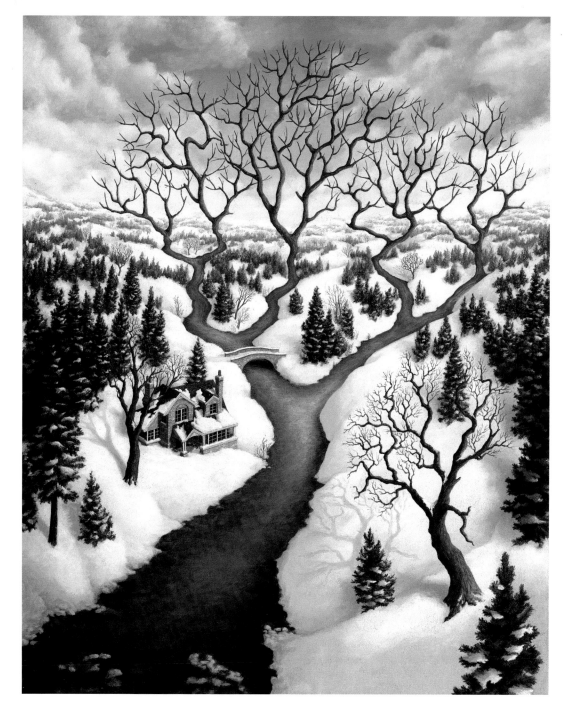

ROB GONSALVES

Tributaries, 1995

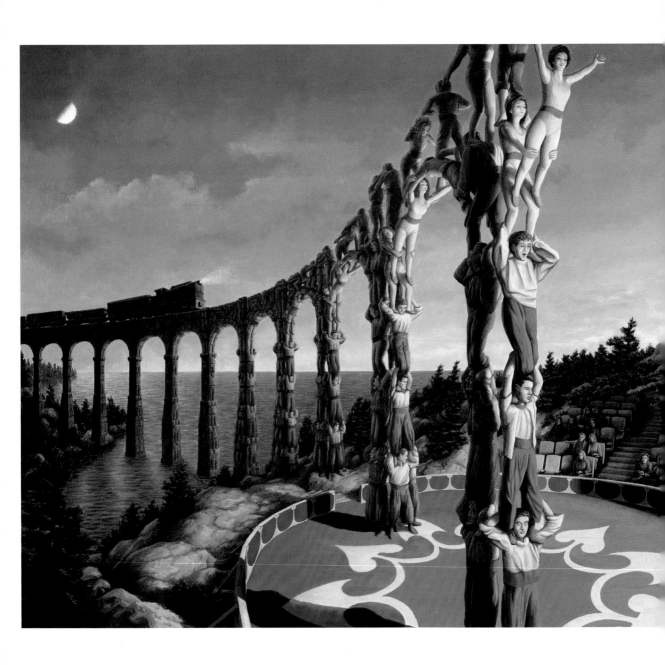

ROB GONSALVES

Acrobatic Engineering, 1999

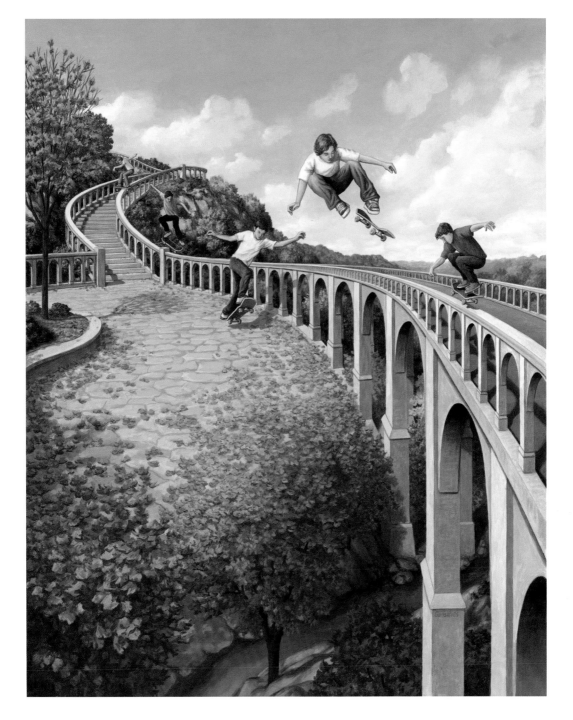

ROB GONSALVES

Big Air, 2011

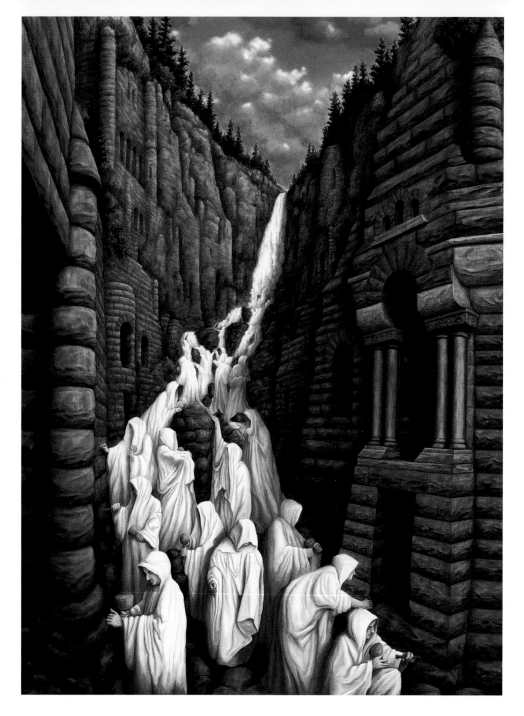

ROB GONSALVES

Carved in Stone, 1995

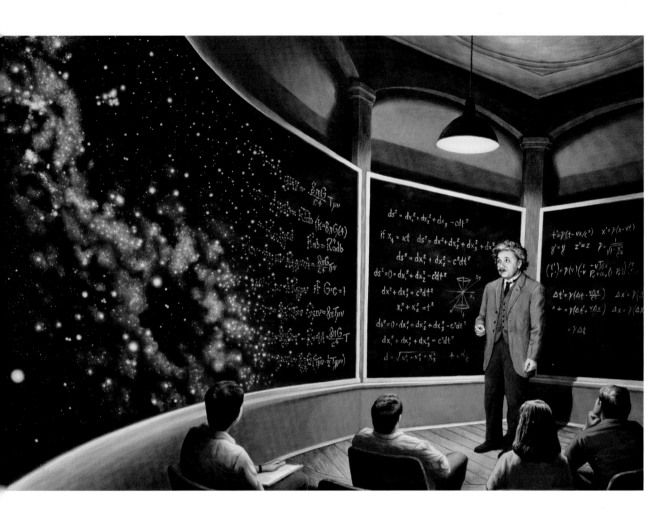

ROB GONSALVES

Chalkboard Universe, 2010

ROB GONSALVES

Community Portrait, 1998

ROB GONSALVES

Table Top Towers, 2003

DANIEL PICON

Bent Squares, 2010
Does this series of squares appear to be warped?

DANIEL PICON

Warped Circles, 2010
The twisted cord pattern on the circles, along with the background image, gives the appearance that these circles are warped.

Moving Circles, 2010
The circles appear to be rotating.

DANIEL PICON

Bulging Circle, 2010
The circle in the center of this image seems to be convex.

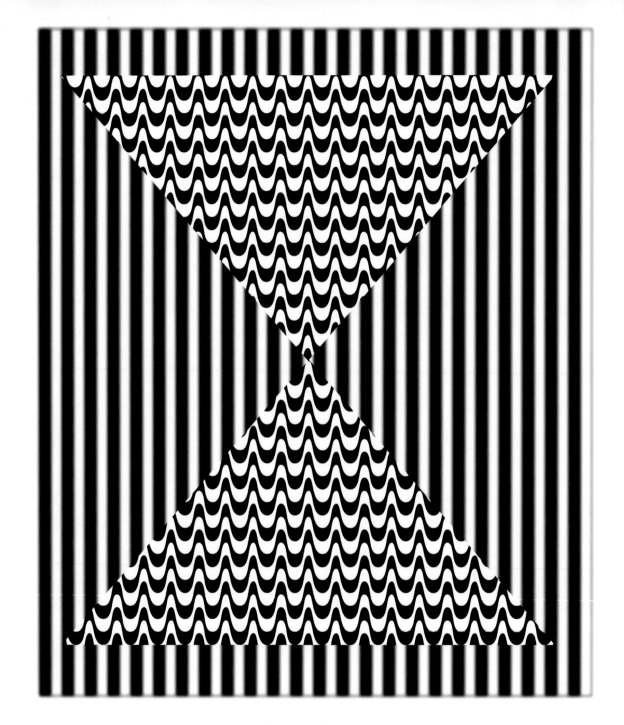

Unstable Triangles, 2010

Stare at this image and the two triangles will appear to be floating on top of the background image.

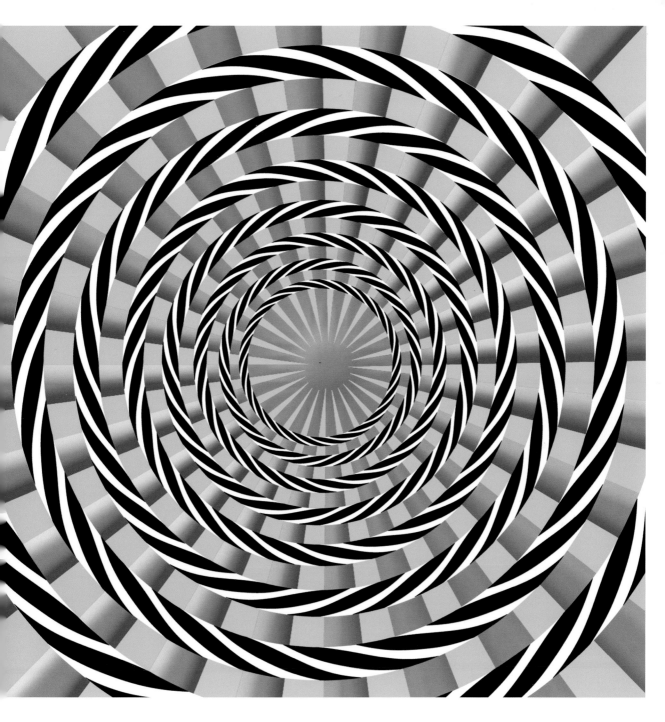

False Spiral, 2010
While this looks like a spiral, it is actually a series of circles. This illusion was first discovered by J. Fraser in 1908.

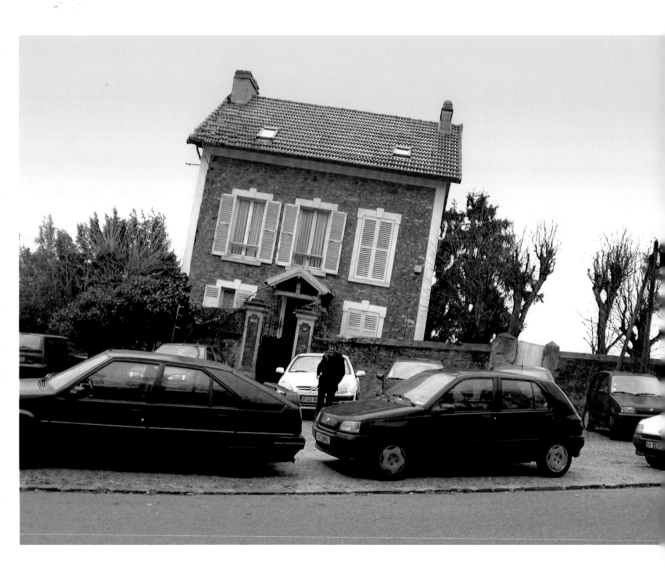

Daniel Picon

Tilted House, 2010
Can you figure out what is going on here? Who would build a house like this? This house is
built on a steep hill and this photograph was taken with the camera parallel to the road.

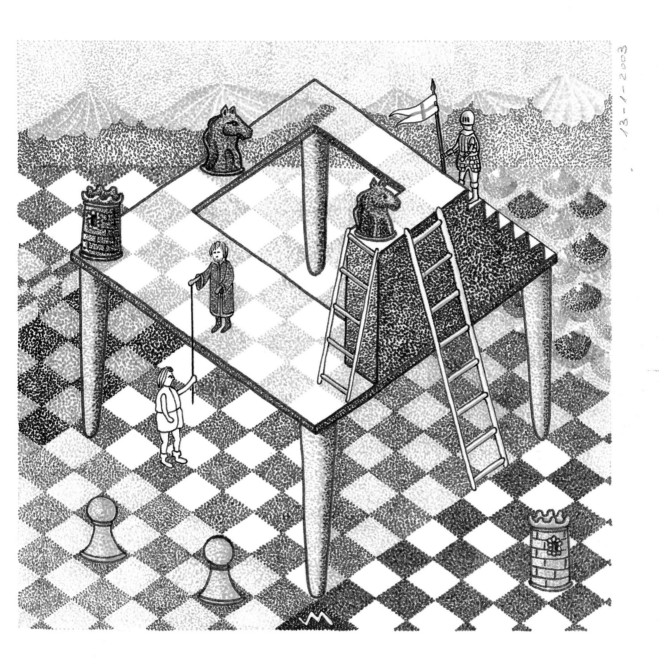

VICENTE MEAVILLA

Impossible Chess, 2003

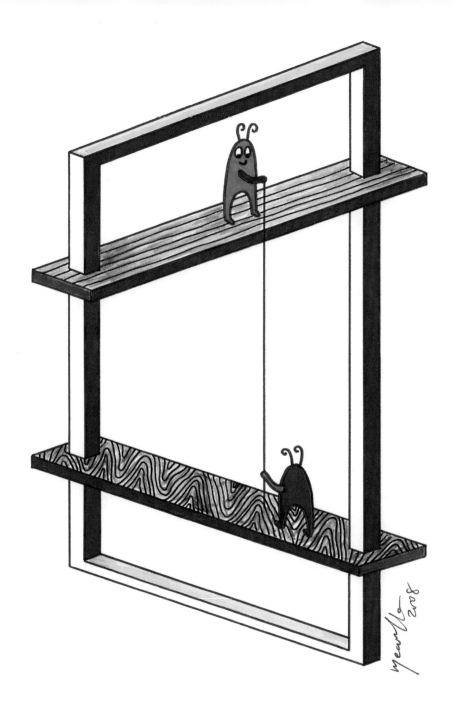

VICENTE MEAVILLA

Impossible String [15], 2008

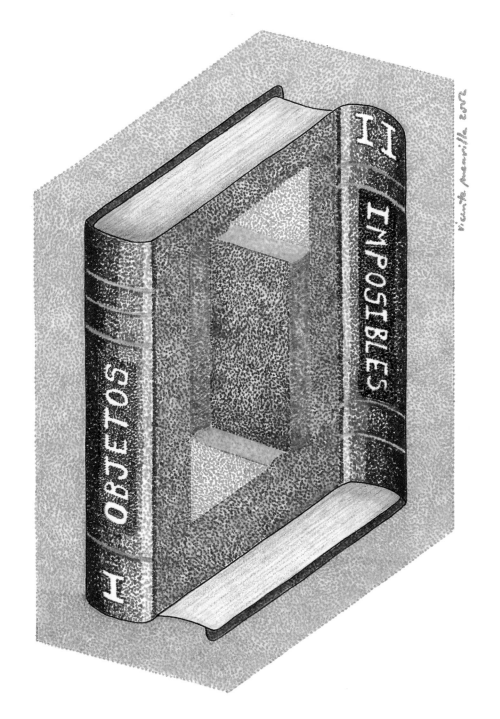

VICENTE MEAVILLA

One Book, Two Books?, 2002
How many books are in this picture?

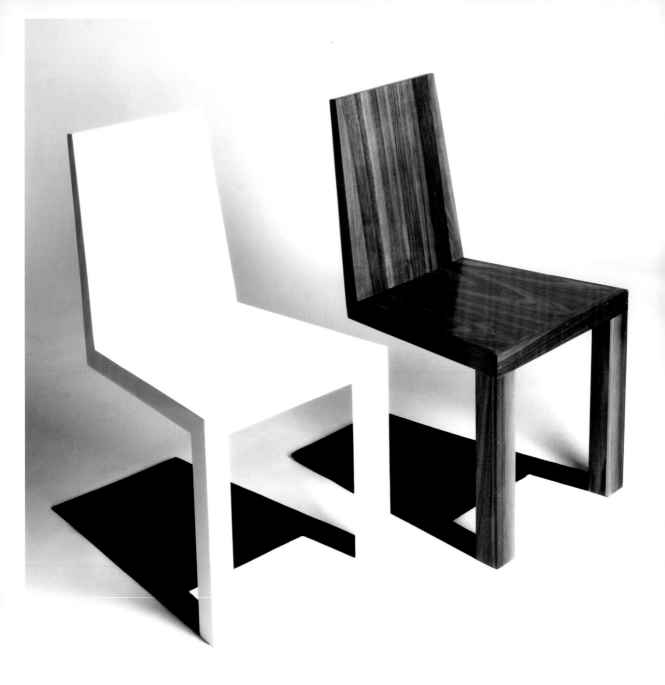

CHRISTOPHER DUFFY

Shadow Chairs, 2009

At first glance, these simple wooden chairs seem to defy gravity by standing upright while only having
two front legs. Closer inspection reveals that the shadow is actually part of the chair.

3D Rx, 2009
Stare at this picture to try to find the hidden image. (See page 220 for reveal.)

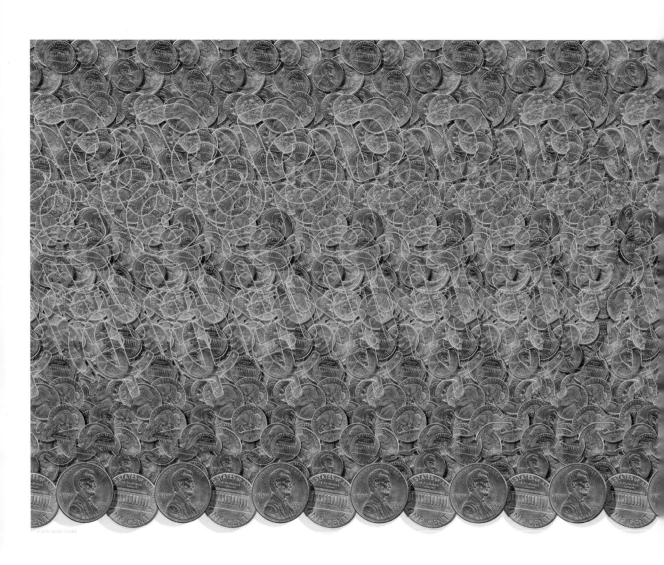

GENE LEVINE

Good Cents, 2010
Stare at this picture to try to find the hidden image. (See page 220 for reveal.)

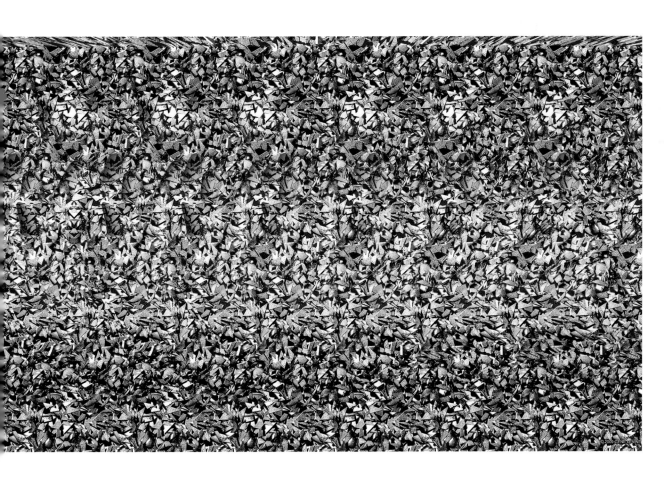

GENE LEVINE

Hand-Eye Coordination, 2009
Stare at this picture to try to find the hidden image. (See page 220 for reveal.)

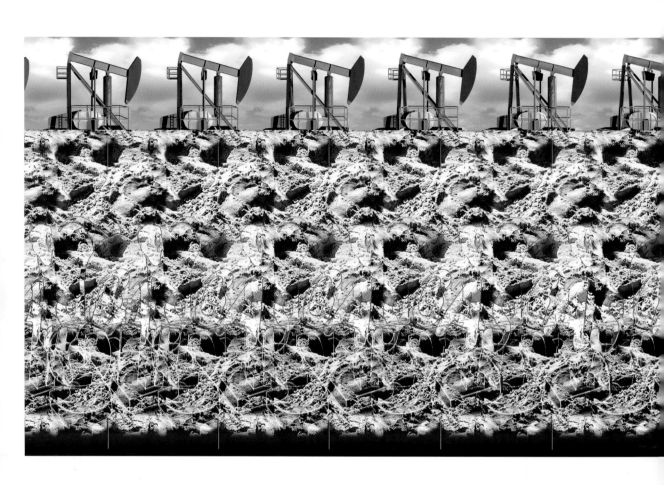

GENE LEVINE

Pump It Up, 2010
Stare at this picture to try to find the hidden image. (See page 220 for reveal.)

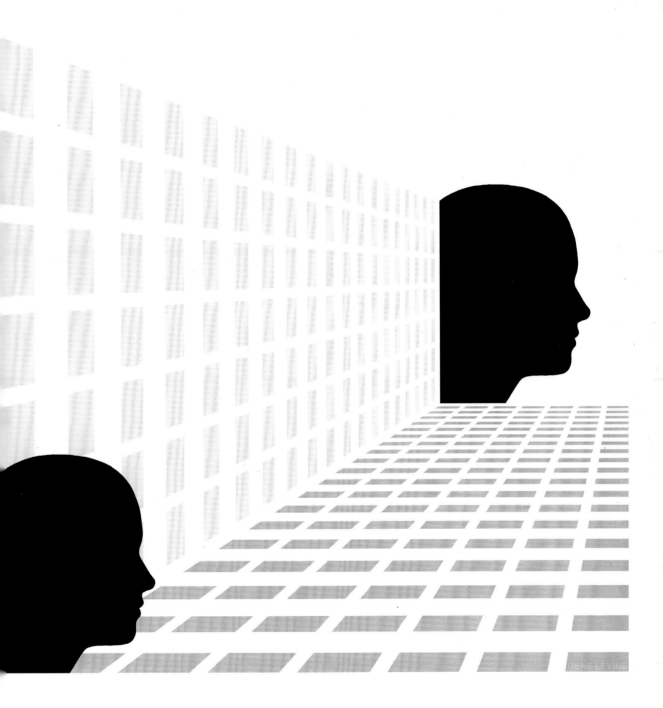

Spatial Profile, 2011

Does one profile appear to be larger than the other? They are identical in size.

GENE LEVINE

Crazy Frame, 2011
The frame bordering this picture is perfectly straight even though it does not appear to be. Try
holding up a straight edge to one of the sides.

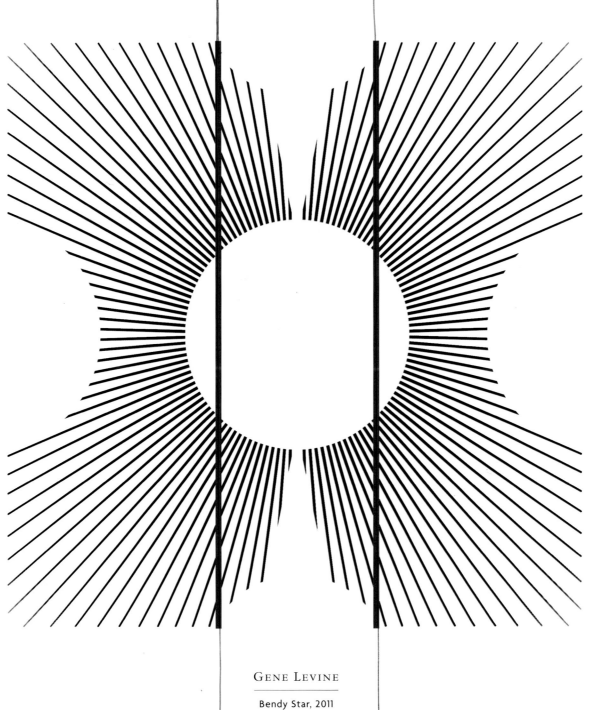

GENE LEVINE

Bendy Star, 2011
Are the red lines straight or curved? Hold up something straight next to them to find out.

GENE LEVINE

Identical Shades, 2011
The red window shades are the exact same size.

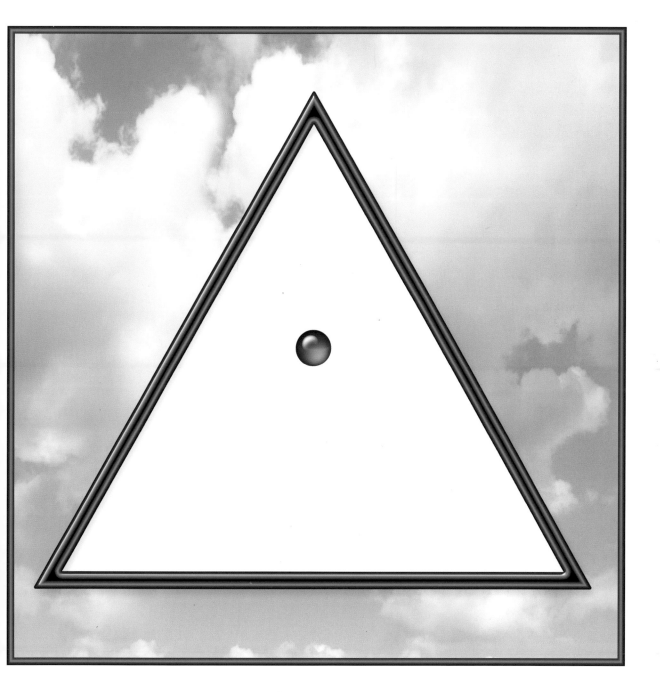

GENE LEVINE

Triangle Height Illusion, 2011
Does the blue dot appear to be in the exact center of this triangle? Measure the
distance above and below it to make sure.

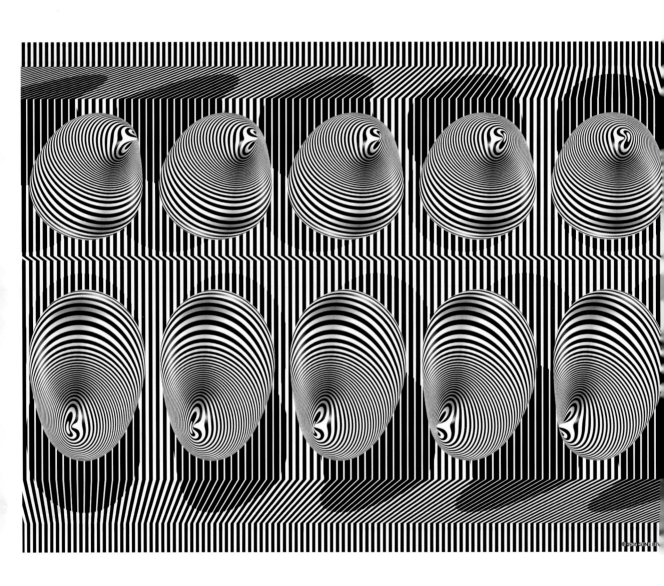

GENE LEVINE

Tear Tiers, 2005
Stare at this image and the striped teardrops will appear in 3D.

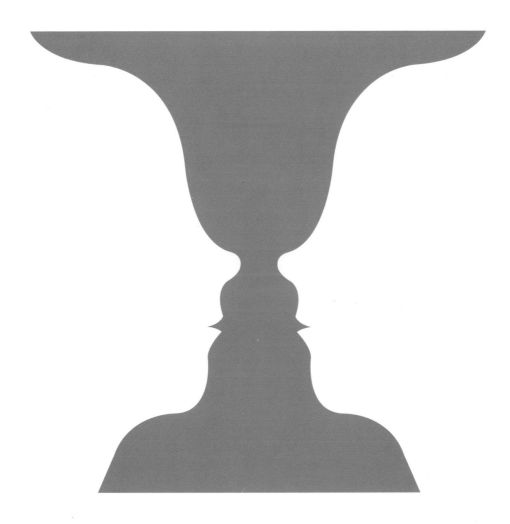

ANDREW FLING

Figure-Ground Vase, 2009
What do you see here—a pair of faces or a vase? This illusion is sometimes called the Rubin Face as it
was first introduced by Danish psychologist Edgar Rubin in the early 1900s.

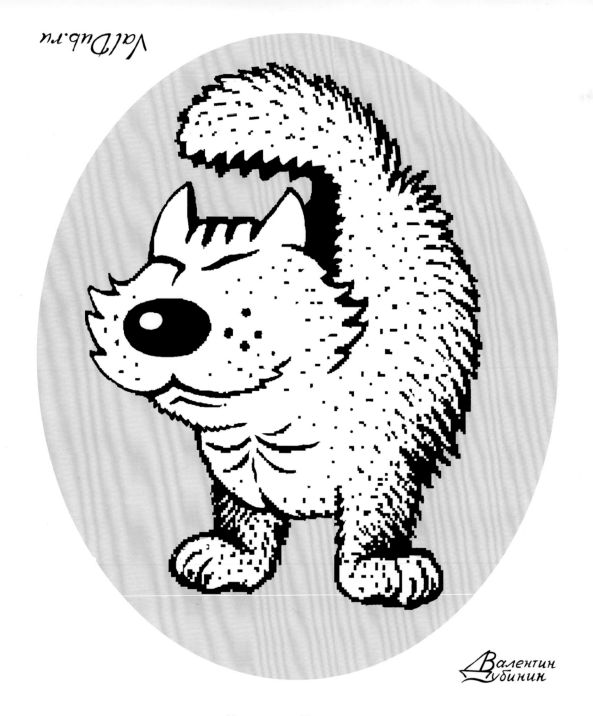

VALENTINE DUBININ

Cat and Dog, 2010
A feline becomes a canine when turned upside down.

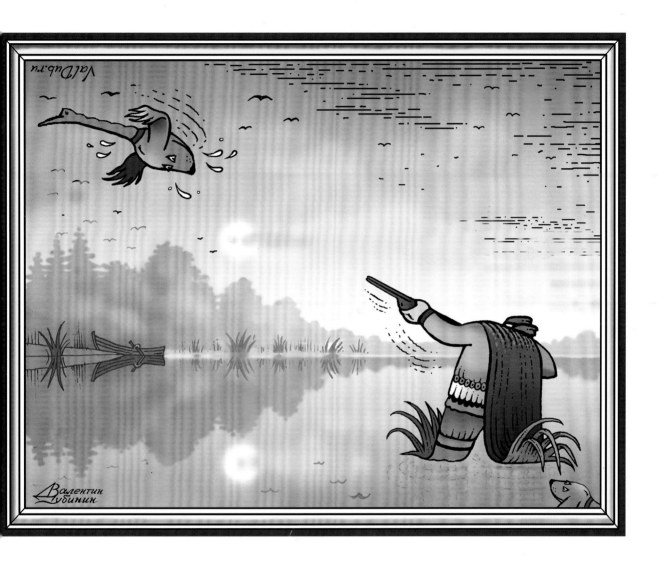

VALENTINE DUBININ

Duck Hunting, 2010

A duck hunter firing his weapon becomes a bird and a swimming dog when turned upside down.

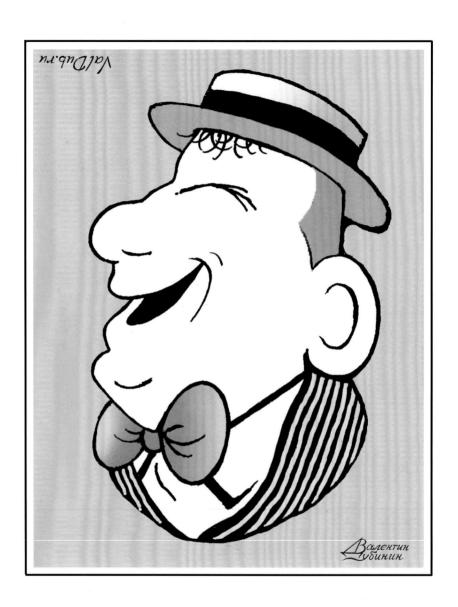

Valentine Dubinin

Kindness and Anger, 2010

A smiling man wearing a hat and a bow tie becomes an angry man wearing glasses when turned upside down.

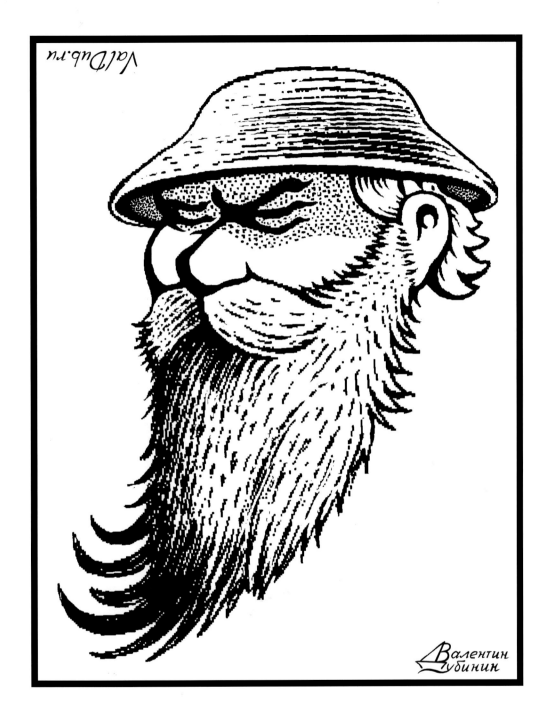

VALENTINE DUBININ

The Peasant and the Rooster, 2010
A bearded peasant wearing a hat becomes a rooster eating from a dish when turned upside down.

А.С.Пушкин

VALENTINE DUBININ

Portrait of the Storyteller, 2010
The profile of a man's face is hidden within this fantasy landscape. Can you find it?

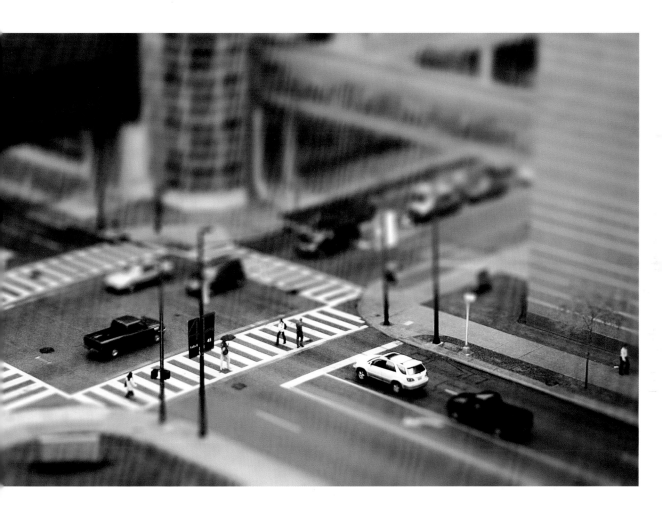

SAMUEL HOUSE

Tilt Shift Street Scene, 2007
While this photograph may look like a miniature model, it is actually a real-life scene. The
photograph has been digitally manipulated to give it the appearance of a fake miniature still.

Pittsburgh Zoo
& PPG Aquarium

PITTSBURGH ZOO

Zoo Illusion, 1994
Aside from the tree, what else do you see in the Pittsburgh Zoo's logo?

158 | GALLERY

JOSÉ MARÍA YTURRALDE

Impossible Circle, 1972

JOSÉ MARÍA YTURRALDE

Impossible Square, 1972

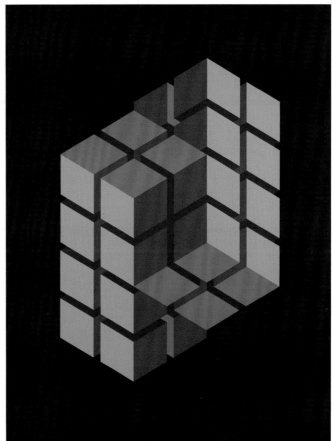

JOSÉ MARÍA YTURRALDE

Impossible Figures, 1973

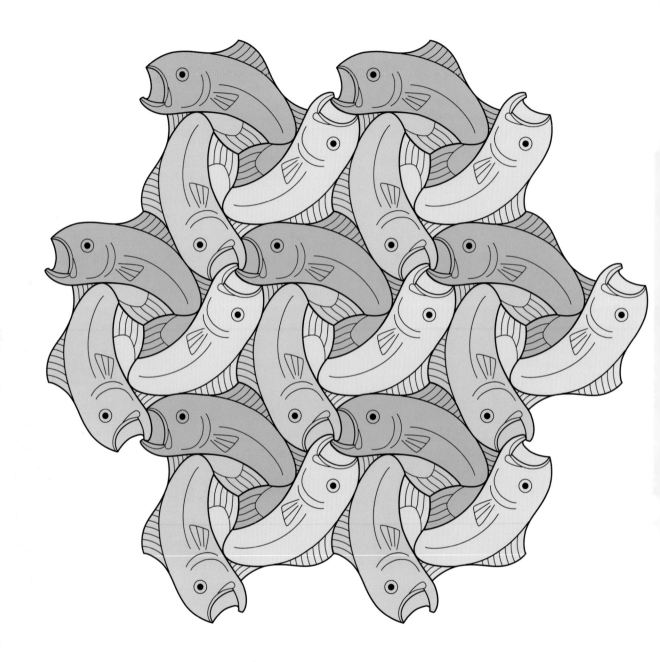

ROBERT FATHAUER

Three Fishes, 1994
This tessellation design has a three-fold rotational symmetry around the tail, top fin, and mouth of each fish.

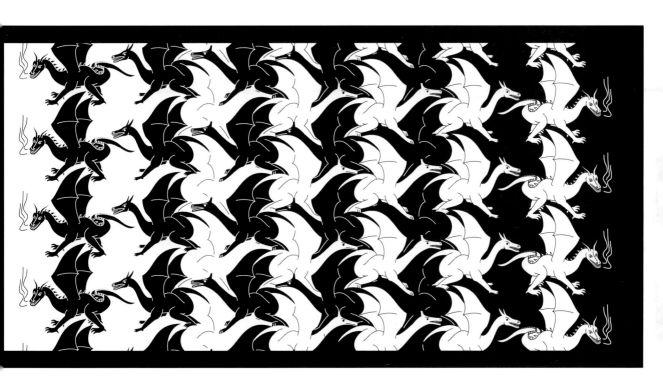

ROBERT FATHAUER

Dragon Metamorphosis, 2003
The eye perceives black dragons on a white background on the left side and white dragons on a black background on the right side. The center presents a tessellation of dragons in which no background is visible.

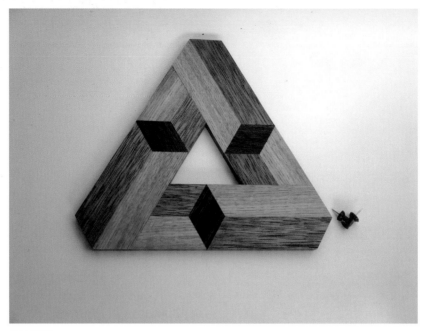

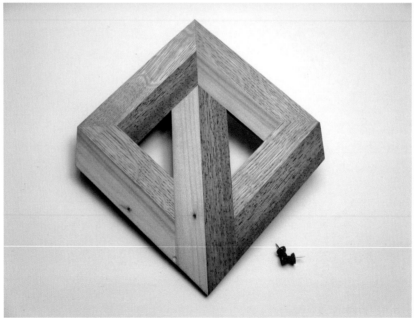

HANS DE KONING

Poetry in Wood, 2002

These impossible objects are made entirely from wood. Although they appear to have depth to them, they are perfectly flat. The artist used three different kinds of wood to create these and finished each piece with oil and wax.

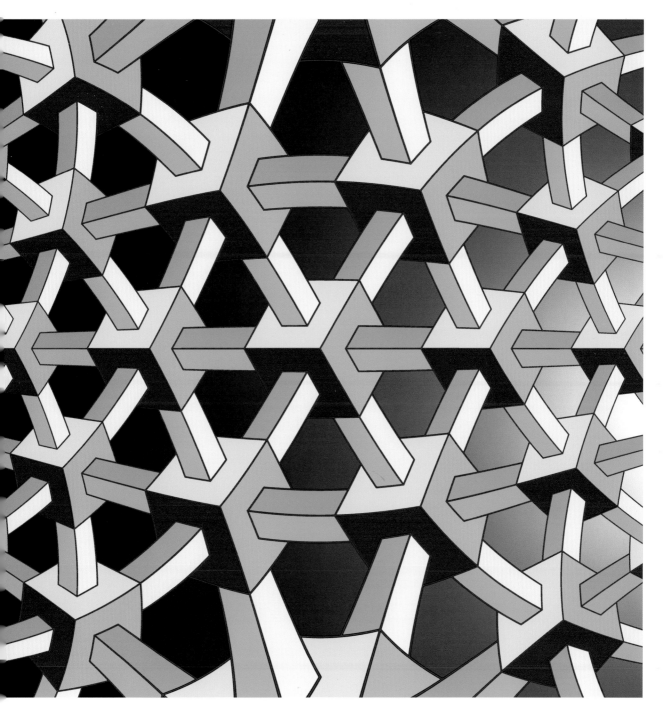

3D30, 2003
In creating this work, the artist took inspiration from Oscar Reutersvärd and M.C. Escher.

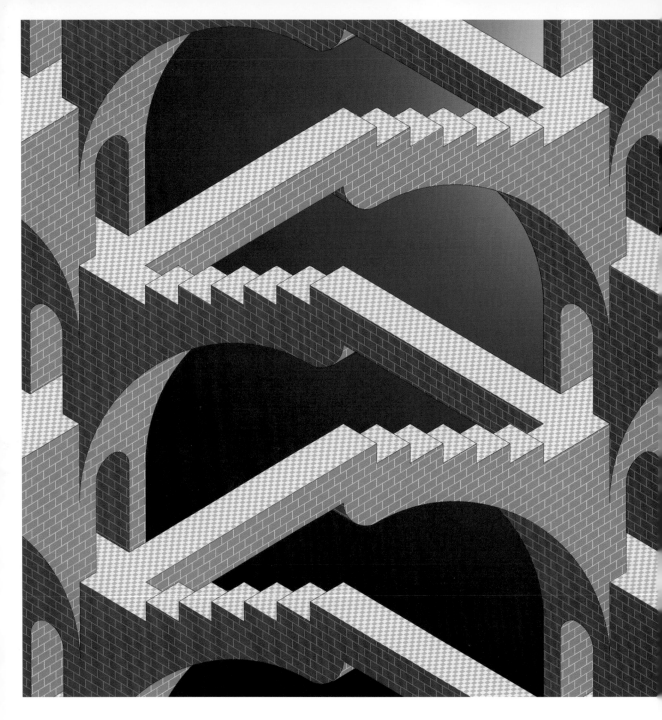

JOS LEYS

Engineer's Nightmare (Close-Up), 2003
Good luck to the engineer who is tasked with building this series of impossible stairways.

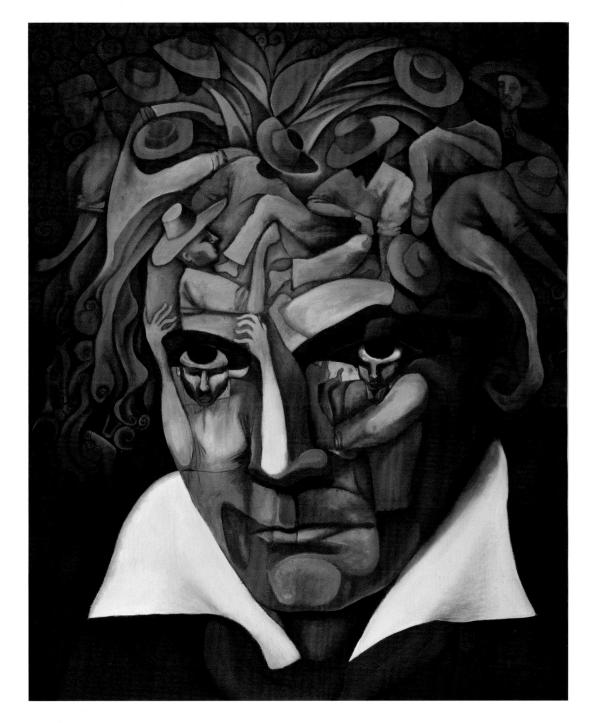

PAUL N. GRECH

Beethoven's 5th, 2003
Can you find all of the people that compose this portrait of Ludwig van Beethoven?

OONA RAISANEN

Disappearing Circle, 2007
Stare at the red dot and the blue circle will disappear.

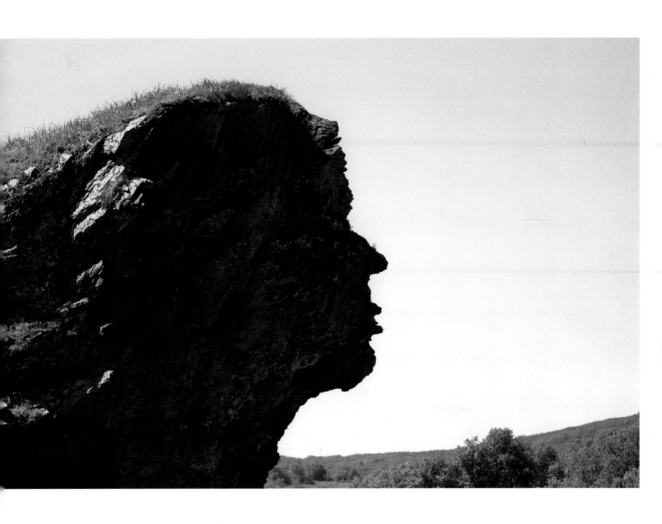

P. Lutus

Face in the Rock, 2004
Do you see the profile of a face in this rock? This picture was taken from a
kayak in the Uyak Inlet on the west side of Kodiak Island, Alaska.

MERLIN DUNLOP

Impossibottle, 2007

How did that get in there? Impossible bottles were made popular by magician Harry Eng who was famous for putting objects into bottles that were bigger than the neck without damaging the actual bottle. Some of his bottles have been purchased by collectors for several thousand dollars.

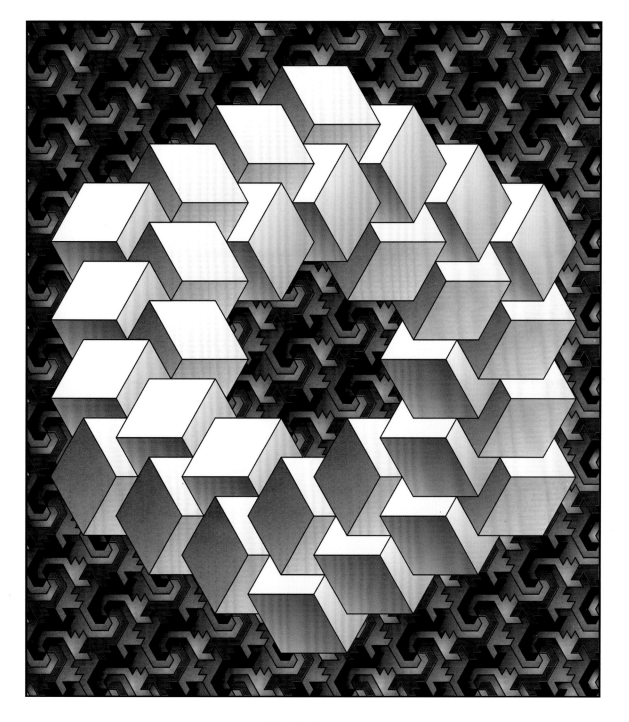

TAMÁS FARKAS

Magic Crystal VI FT, 1976

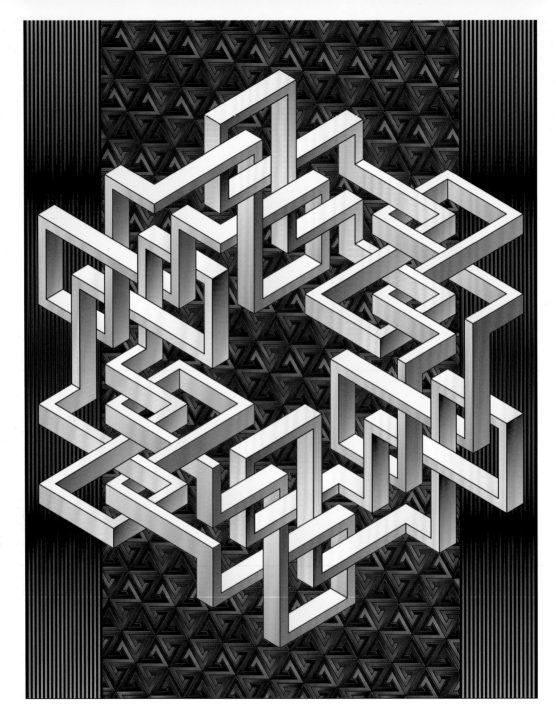

TAMÁS FARKAS

Paradox Dimension VI IX, 2010

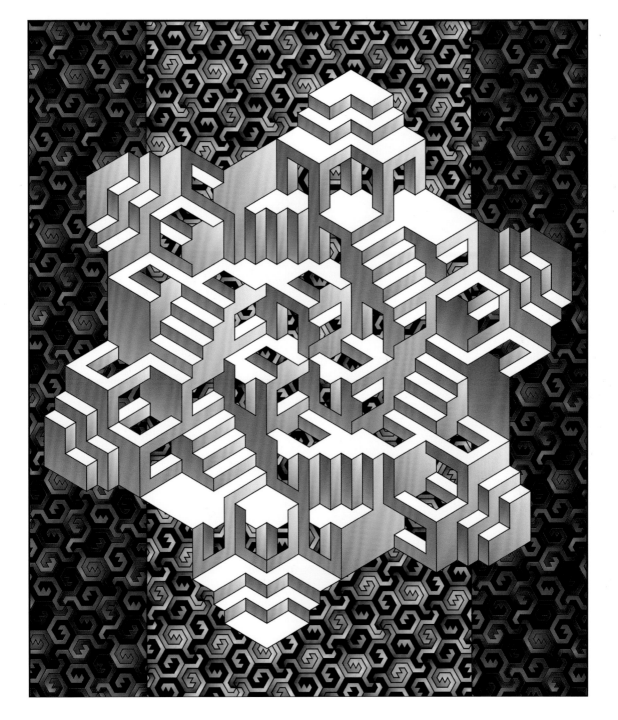

TAMÁS FARKAS

Dimension Labyrinth FT, 2002

NICHOLAS WADE

Rebecca, 1978

This photo-graphic image was created by combining a photograph and a design drawn with pen and ink. The portrait of
a smiling young girl can be seen by either viewing it from a distance or blurring the picture by squinting.
This originally appeared in the book *Visual Allusions: Pictures of Perception* published in 1990.

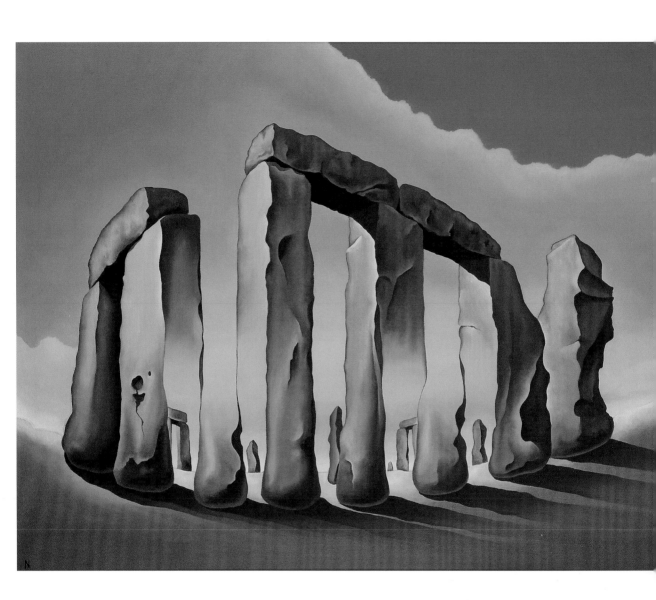

NORMAN PARKER

The Stone Circle, 1984
Something is wrong with this circle of stones. The alternate title for this painting is "Illusion in Stone."

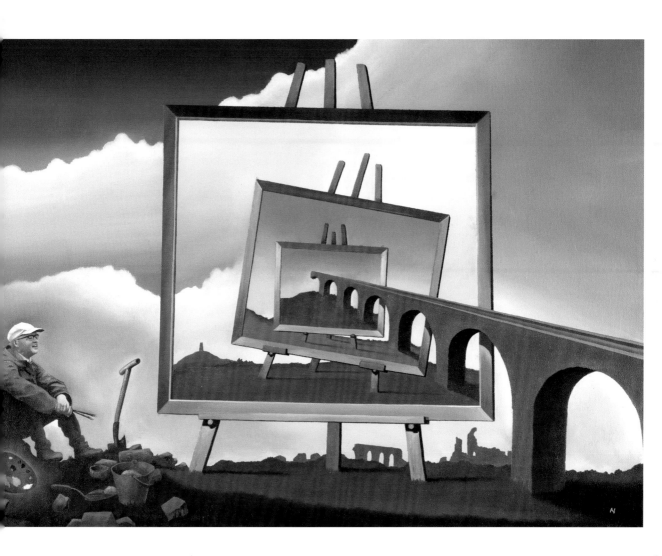

NORMAN PARKER

Study for an Impossible Viaduct, 2007
A viaduct appears to emerge into reality from a series of paintings.

LUBOV NIKOLAEVA

Foggy Morning, 2003

LUBOV NIKOLAEVA

Dreams, 2003

LUBOV NIKOLAEVA

Olesya, 1992
Can you find the woman hidden among the foliage?

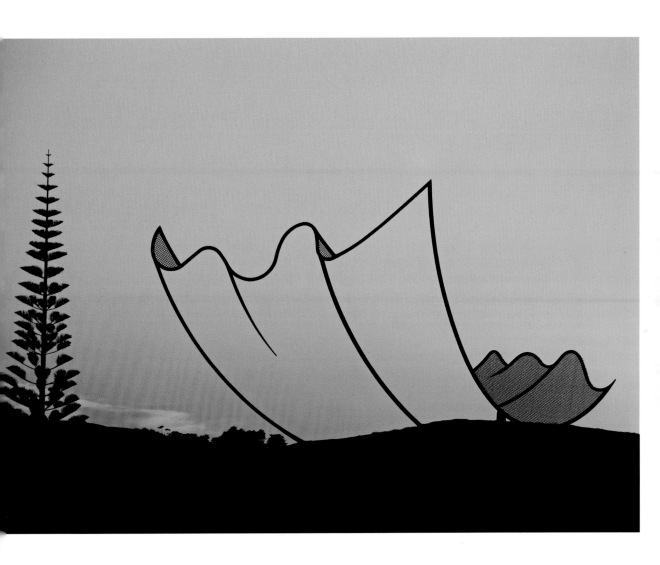

Neil Dawson

Horizons, 2011
While it may seem hard to believe, this an actual sculpture made entirely of welded and painted steel located at "The Farm" in Kaipara, New Zealand. When viewed from certain angles, the structure appears to be a sheet of paper floating gently to the ground.

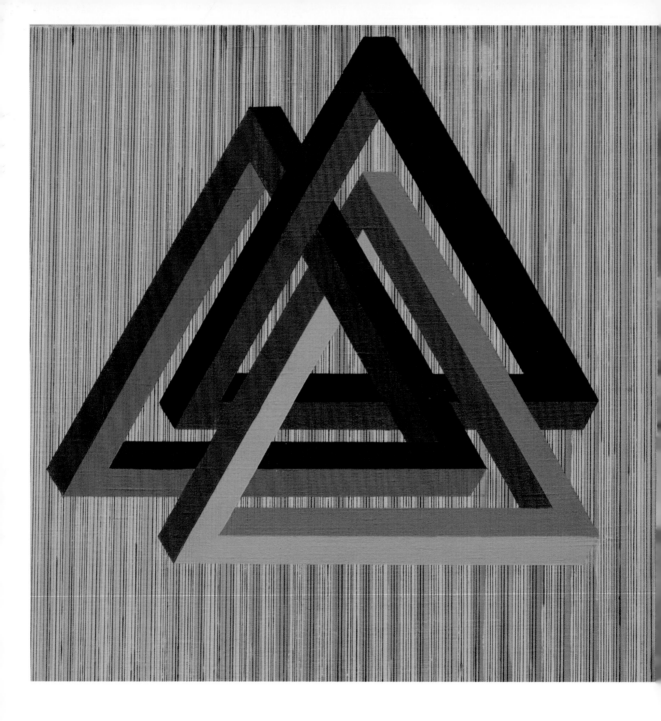

MONIKA BUCH

Untitled, 1987

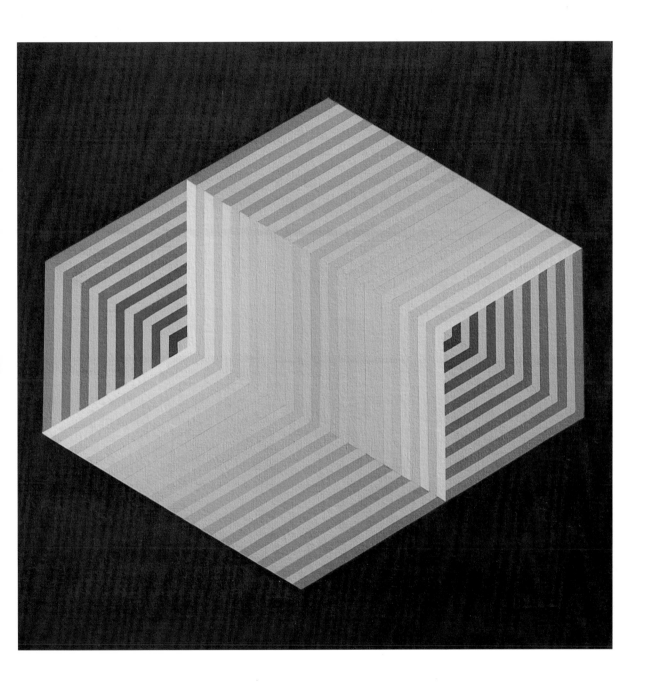

MONIKA BUCH

Untitled, 1984

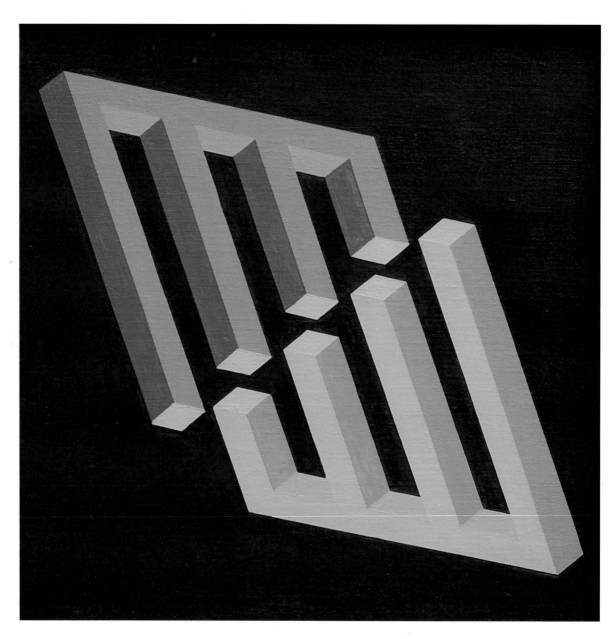

MONIKA BUCH

Untitled, 2007

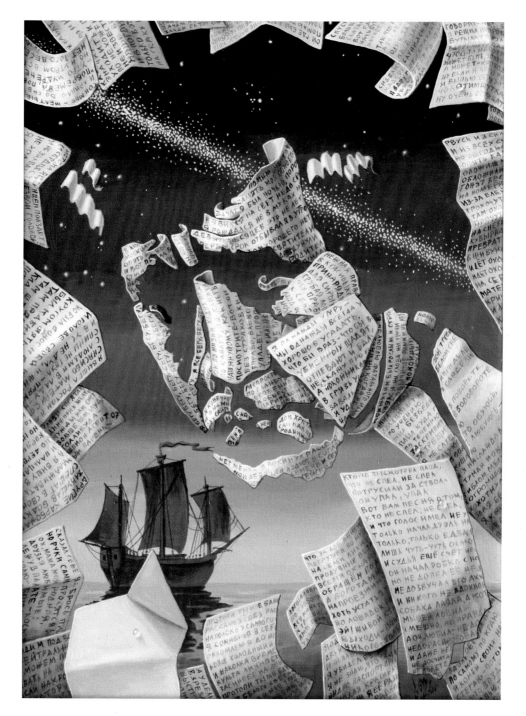

Victor Molev

Vysotzkiy, 2006

The portrait of a man is hidden amongst these scattered papers. Can you find him?

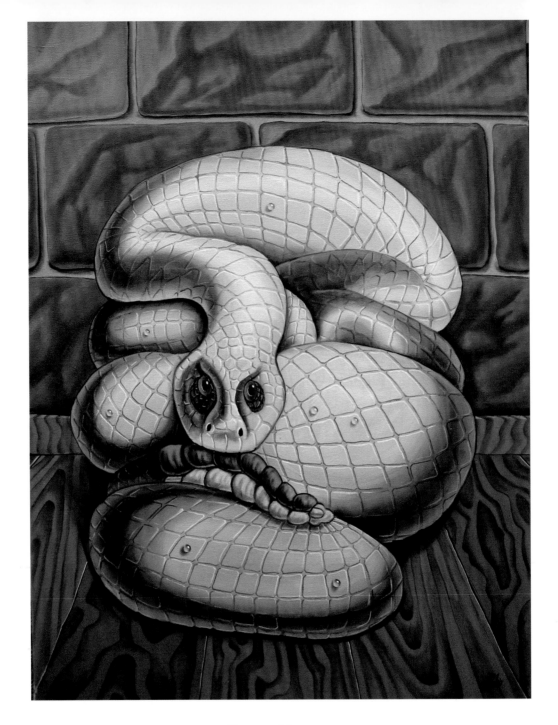

VICTOR MOLEV

Snake, 2007
At first glance, this appears to be nothing more than a balled-up snake. Do you also see the hidden face?

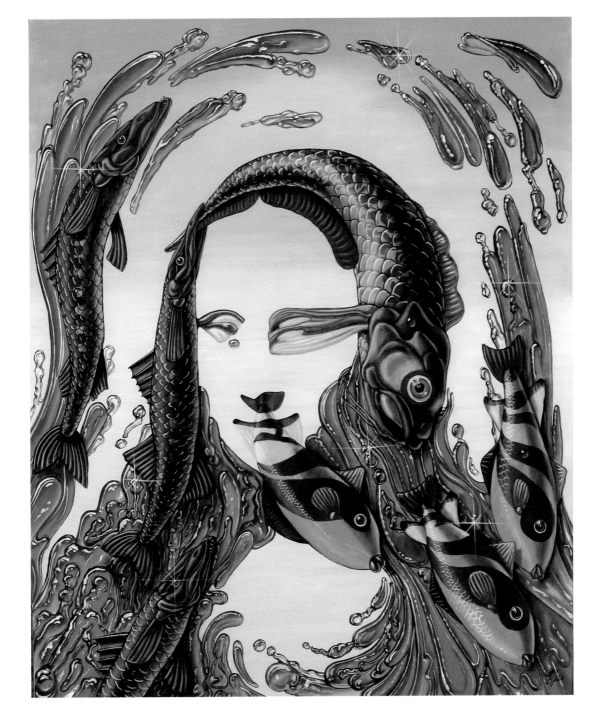

Mona Lisa (Water), 2007
Do you see a portrait of Mona Lisa in this scene?

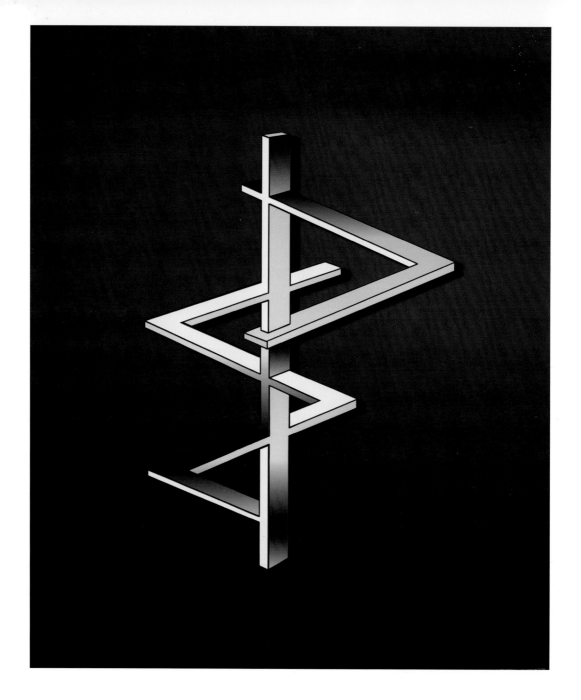

ALAN KING

Impossible Totem, 2006
The angled portions of this totem intersect the center column in an impossible manner.

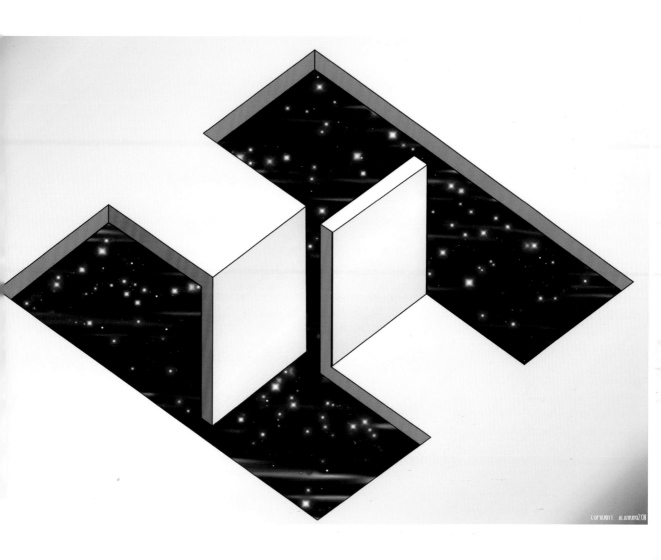

ALAN KING

Perihelion (Tribute to Reutersvard III), 2007
This impossible window in the floor was created as a tribute to Oscar Reutersvärd (the father
of the impossible figure) who drew many similar type illusions during his lifetime.

PAUL NASCA

Motion Maze, 2010
Stare at this image. Does it seem to be moving?

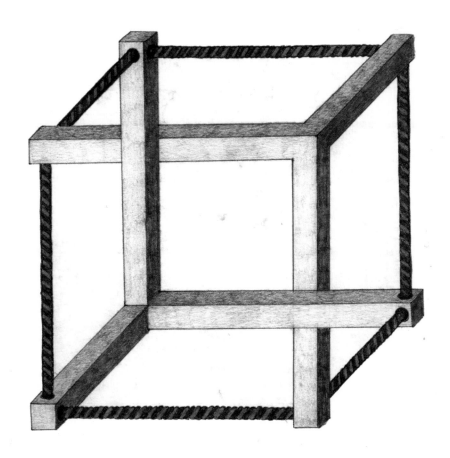

DMITRY RAKOV

The Tessera, 1999
While this may look like a cube at first, it is not. The construction of this object is not physically possible.

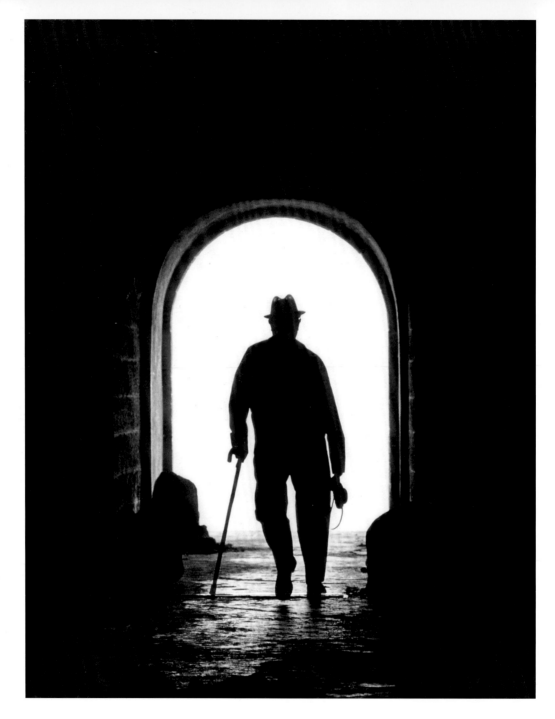

JOAQUIM ALVES GASPAR

The Photographer, 1970
Is this man in this photograph walking toward you or away from you?

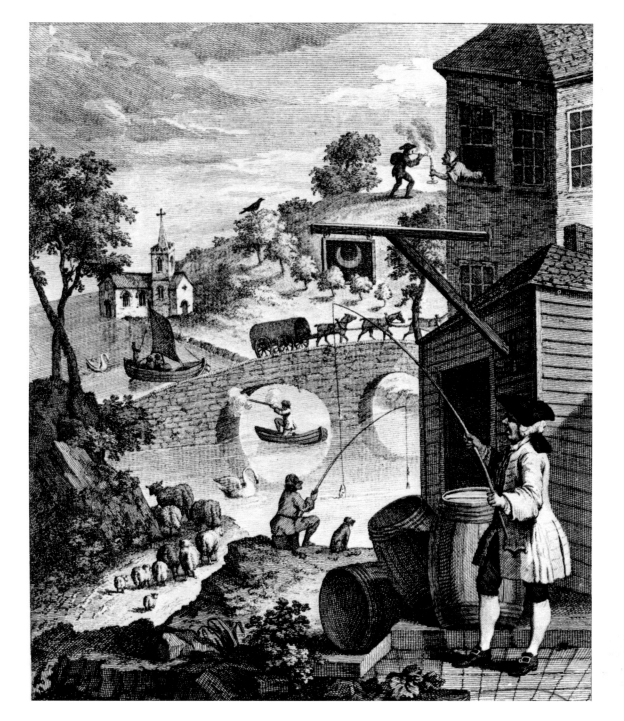

William Hogarth

Satire on False Perspective, 1754
There are many deliberate perspective problems in this picture. Can you find them all?

GIANNI A. SARCONE

Acrobat Girl, 2002
A lady acrobat performing on an impossible ceiling-hung structure.

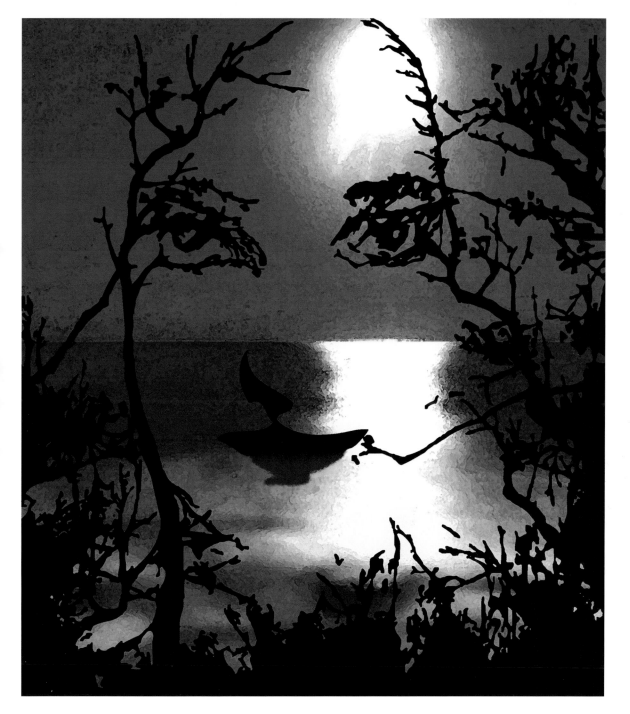

GIANNI A. SARCONE

Twilight Face, 2004
Can you perceive the beauty in this nocturnal ocean panorama lit by the moon?

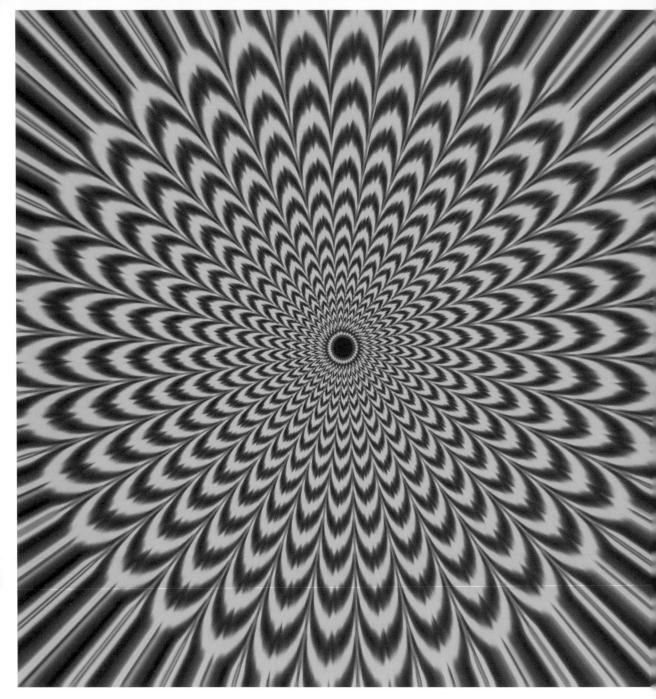

GIANNI A. SARCONE

Vibrating Optical Illusion, 1999
This image appears to vibrate or pulsate when you stare at it.

GIANNI A. SARCONE

Christmas Lights Illusion, 2001

The green and yellow curved lines appear to vibrate and blink forward and backward.

GIANNI A. SARCONE

Ambivalent Woman, 2007

Look at this woman hidden by a shadow. Can you determine which direction she is looking?

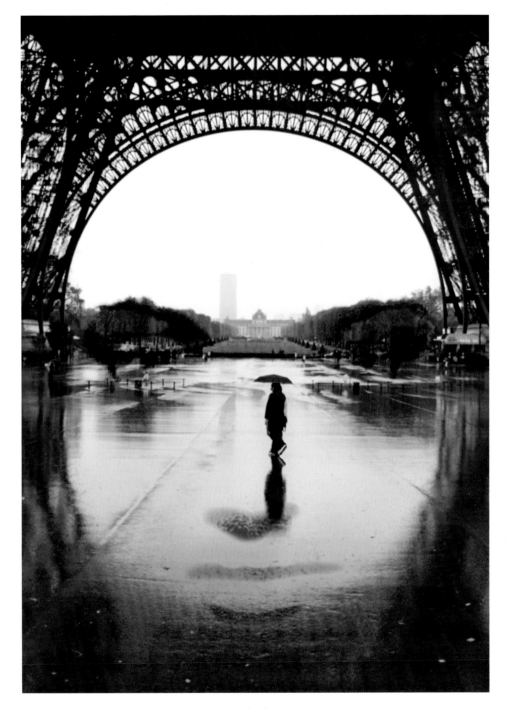

GIANNI A. SARCONE

Another Face of Paris, 1998
Can you find the face hiding under the Eiffel Tower?

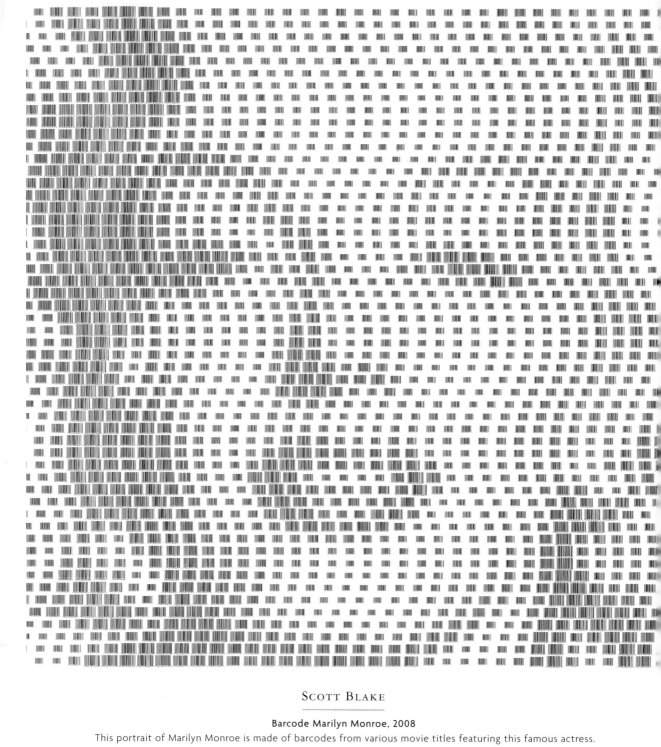



SCOTT BLAKE

Barcode Marilyn Monroe, 2008
This portrait of Marilyn Monroe is made of barcodes from various movie titles featuring this famous actress.

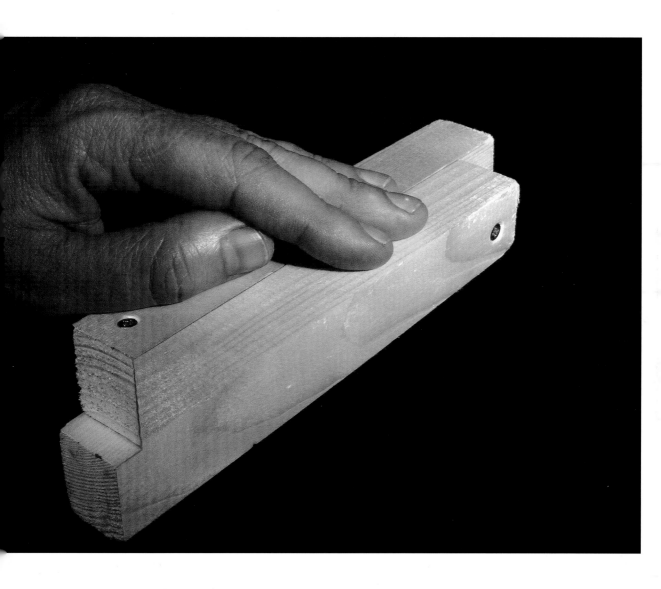

ERIK MINNEMA

Side by Side???, 2009

A real life impossible object based on an original idea from Dutch physicist and teacher Bruno Ernst.

ERIK MINNEMA

The Way to the Top, 2008
The left side of this impossible chess board appears to be a series of steps while the right side is perfectly flat.

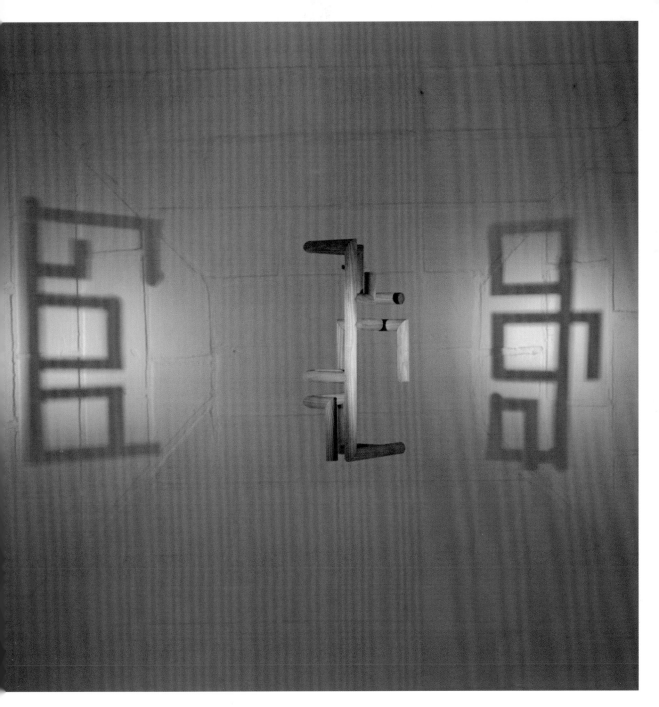

FRED EERDEKENS

God/Ego, 1990
Light cast different ways on this object reveals two different words formed from shadows.

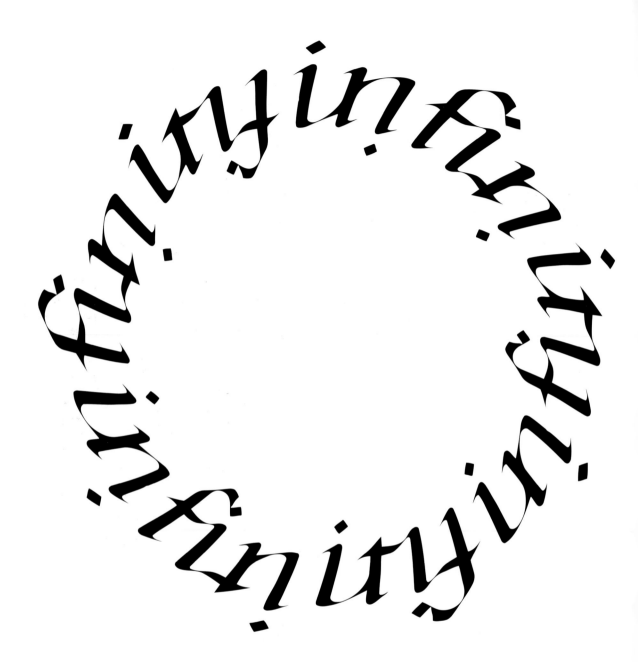

Infinity Circle, 1981
The word INFINITY repeats infinitely when reading this circular pattern.

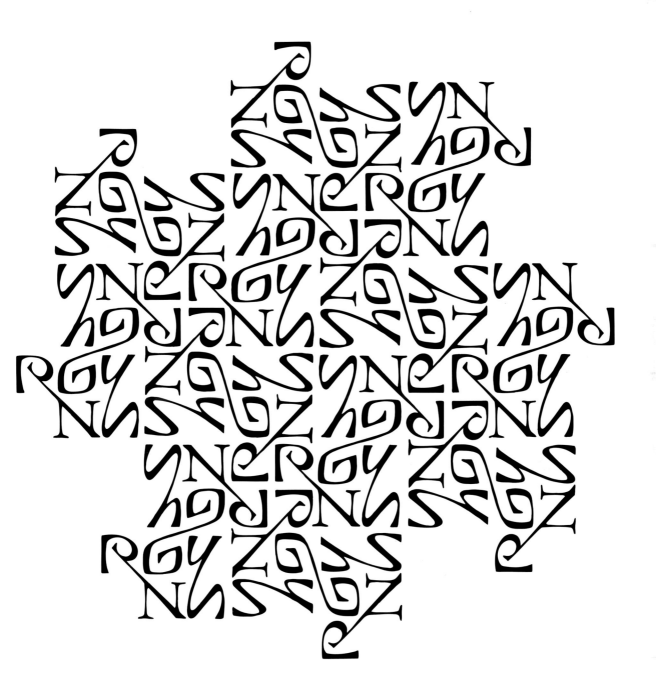

Scott Kim

Synergy, 1981

This word-based tessellation pattern repeats the word SYNERGY around two centers of rotation. The letters S and E also double as the letters Y and R, respectively, when read from different directions.

Communication, 1981
This hyphenated word looks identical when read right side up or upside down.

Scott Kim

Swords into Plowshares, 1992
The word SWORDS slowly morphs into the word PLOWSHARES.

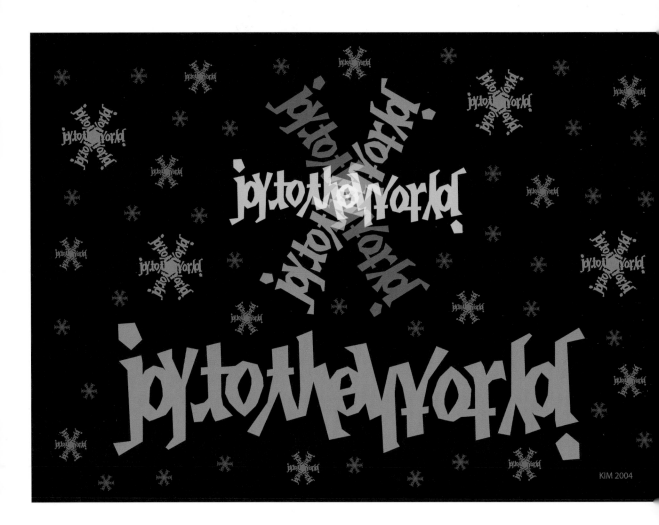

KIM 2004

Scott Kim

Joy to the World, 1985

This 180-degree rotational ambigram was originally created by the artist as a family holiday card. To help create the angular letters, he cut shapes from construction paper and traced them into the computer.

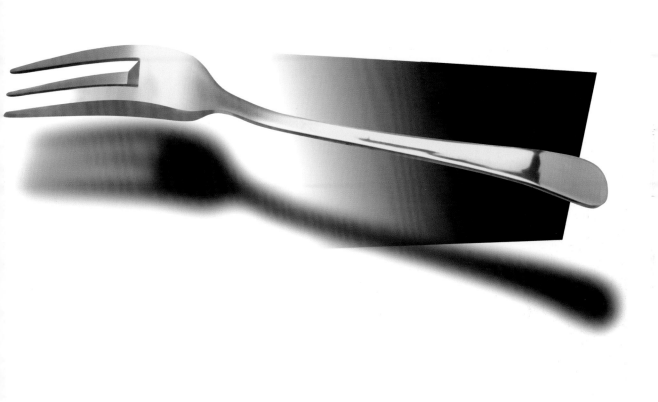

SYD MANNION

Impossible Fork, 1997
Something is not quite right with this fork. The photographer, Syd Mannion,
won first prize in a photographic competition in New Zealand with this image.

DICK TERMES

Trees Second Chance, 1976
Shadows from dead trees find new life amongst the living.

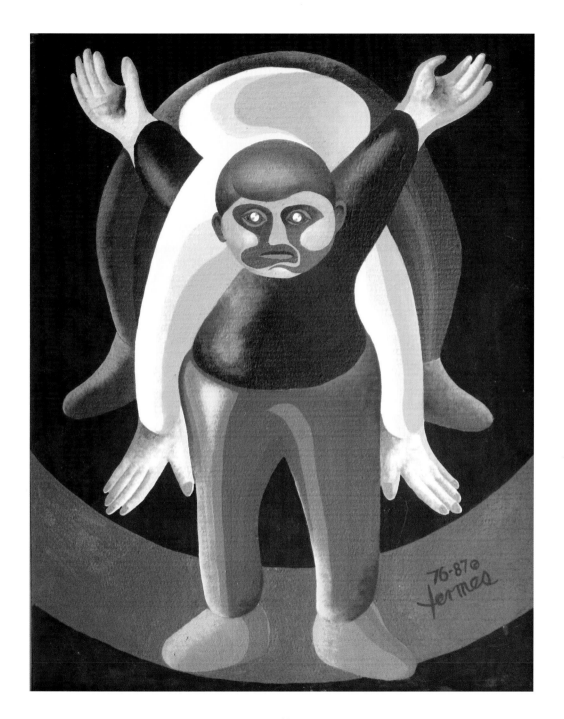

Dick Termes

A Head, 1987
To which gentleman does the head belong?

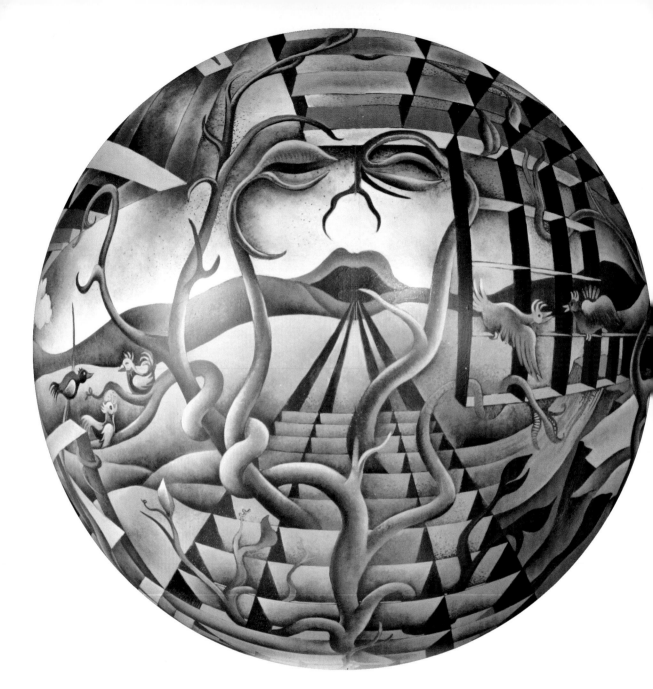

DICK TERMES

Six Senses, 1993

This artist (here and on facing page) paints on spheres rather than on flat canvas. Each sphere represents an entirely closed universe representing one complete world or environment. They capture the up, down, and all around visual world from one revolving point in space.

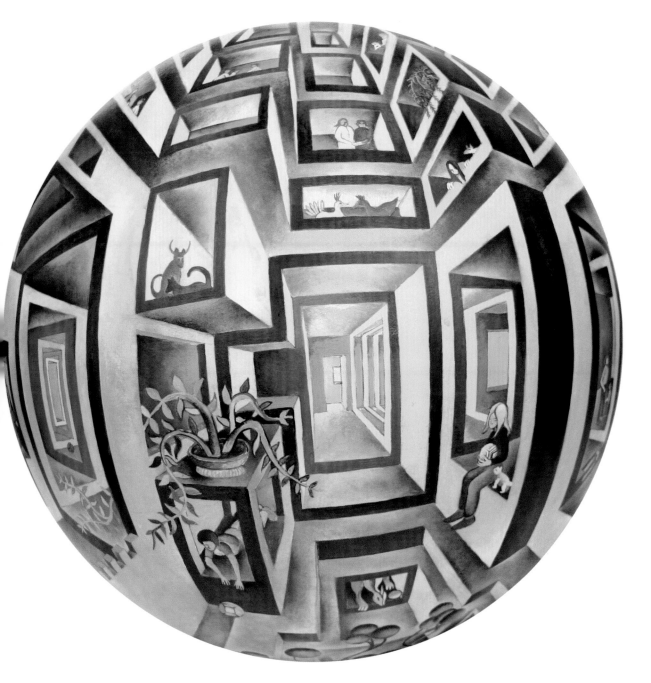

DICK TERMES

Cubical Universe, 2010

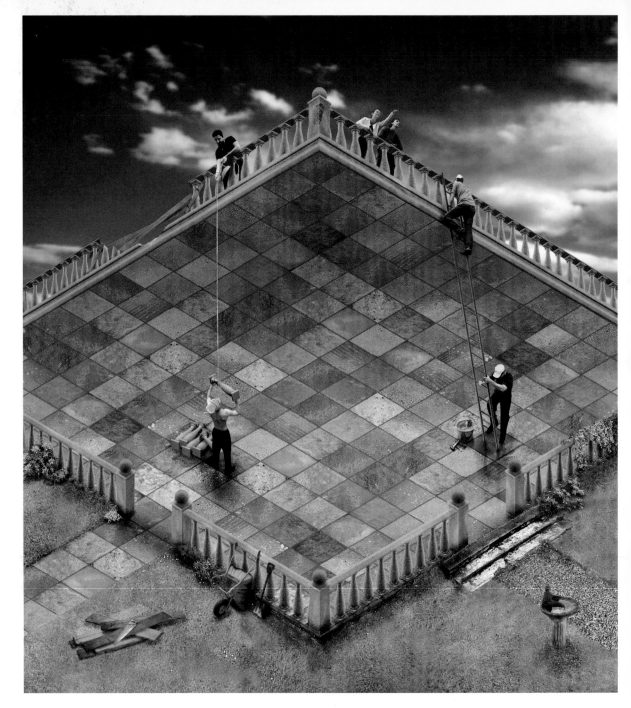

DAVID MACDONALD

The Terrace, 1998
This image is the most popular work by creative artisan David Macdonald. It
is a derivative of the *Folded Chessboard* by Sandro Del-Prete.

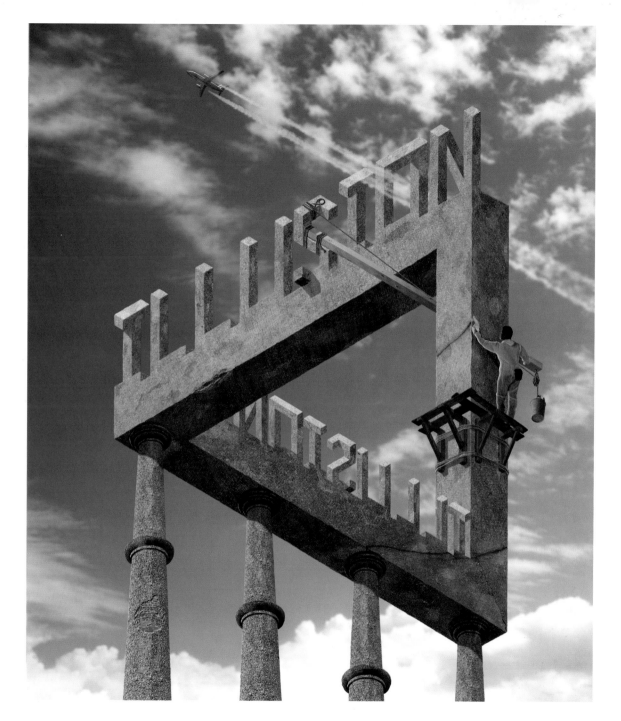

David Macdonald

Science & Vie Cover, 2008

This illusion was designed for a French science magazine for younger readers and is based upon the Penrose triangle.

DAVID MACDONALD

The Other Side of the Mirror, 2010
Two young women ascend a set of stairs and cross paths. Are they each looking in a mirror simultaneously?

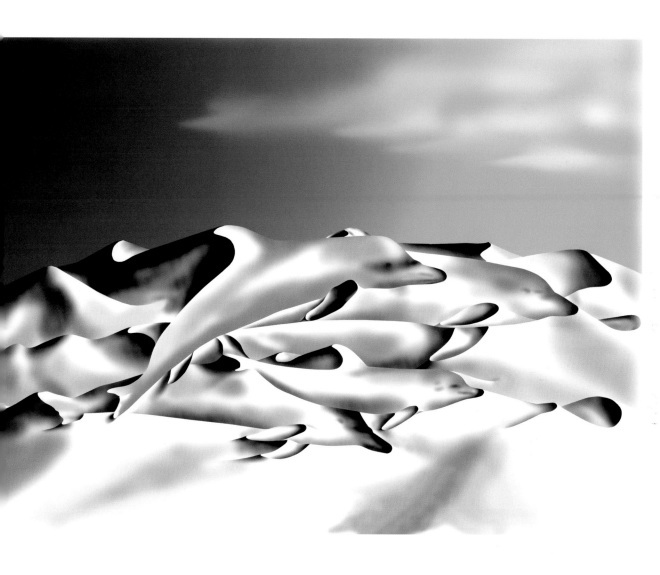

DAVID DORY

The Hidden Pod, 2007
Hiding in this sand dune are four dolphins. Can you find them?

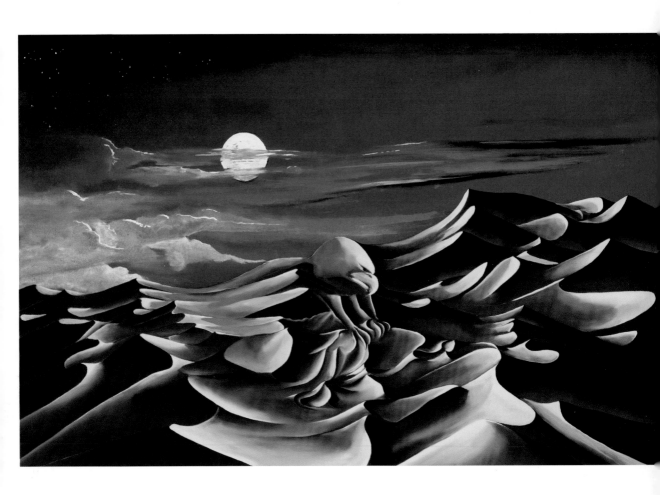

DAVID DORY

Spirit Hunter, 2011
The spirit of an eagle swoops down on a snake in this surreal sand dune while the full moon lights the night.

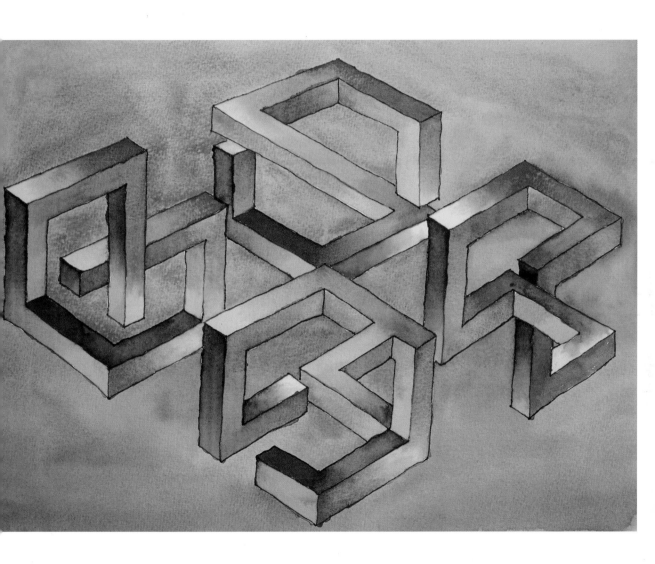

JENS MALMGREN

4 Boxes, 2011
The four boxes presented in this painting are each impossible in their own unique way.

EPILOGUE

I am a great fan of *The Art of the Illusion* co-author Terry Stickels and his work. I'm indebted to him for his books, puzzles, and newspaper columns, which I frequently use in my creative thinking seminars to mentally challenge participants. Consequently, I have waited eagerly for this book, and, to say the least, I am delighted.

This book is an extraordinarily beautiful testament to how illusions provoke the human imagination. When you look at the illusions, a new reality moves in your imagination, as you perceive different and sometimes contradictory images. Sometimes you perceive them sequentially, other times simultaneously. The illusions will reawaken your perceptive abilities. What we are familiar with we cease to see. The optical illusion shakes up the familiar scene, and as if by magic, we see a new meaning and sometimes several meanings in it.

What you look at and what you see can be very different. When you look at a scene, you perceive it passively and simply record it. When you see into a scene, you perceive actively, and your mind constructs the scene in different ways in your imagination.

Many of the illusions in the book, for example the work of M. C. Escher, compel you to see into them so that what you first see is not what you see. Like magic, the lollipop comes at the end when you suddenly see what the artist wanted you to see.

—Michael Michalko

Author, *Thinkertoys: A Handbook of Creative Thinking Techniques; Cracking Creativity: The Thinking Strategies of Creative Geniuses; ThinkPak: A Brainstorming Card Deck* and *Creative Thinkering: Putting Your Imagination to Work*

ANSWER TO PUZZLE

How many squares are in this puzzle?

17

GENE LEVINE REVEALS FROM PAGES 141–144

 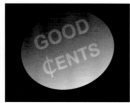

IMAGE CREDITS

Page 6: Public domain image (upper left); Copyright Rafal Olbinksi (upper right), image courtesy of Patinae, Inc., www.patinae.com; M.C. Escher's "Relativity" (bottom left) Copyright 2011 The M.C. Escher Company-Holland, all Rights reserved, www.mcescher.com; Copyright Jos Leys (bottom right)

Page 7: Copyright Rob Gonsalves (upper left), image courtesy of Huckleberry Fine Art, www.huckleberryfineart.com; Copyright Octavio Ocampo (upper right), image courtesy of Visions Fine Art, www.visionsfineartcom; Copyright István Orosz (bottom left); sculpture by Neil Dawson (bottom right), photograph courtesy of David Hartley

Page 8: Copyright John Langdon (upper left); Copyright Valentine Dubinin (upper right); Copyright Ist007án Orosz (bottom left); Copyright David Macdonald (bottom right)

Page 9: Copyright Christopher Duffy (upper left); Courtesy of Frederick Kingdom, Elena Gheorghiu, and Ali Yoonessi, McGill University (upper right)

Page 10: Copyright Rob Gonsalves; image courtesy of Huckleberry Fine Art, www.huckleberryfineart.com

Page 11: Copyright Gianni A. Sarcone, www.archimedes-lab.org, Italy

Page 12: Public domain image

Page 13: Public domain image

Page 14: Courtesy of www.oldpostcards.com and www.ustownviews.com

Pages 15 and 16: Copyright Scott Kim

Page 17: Courtesy of Paul Nasca

Pages 20-25: Copyright Octavio Ocampo; image courtesy of Visions Fine Art, www.visionsfineart.com

Pages 26-28: Copyright Rafal Olbinksi; images courtesy of Patinae, Inc., www.patinae.com

Pages 29-32: M.C. Escher's "Development II", "Balcony", "Symmetry Drawing E11", and "Relativity" Copyright 2011 The M.C. Escher Company-Holland, all rights reserved, www.mcescher.com

Pages 33-35: Ray Massey (photography), AGA (advertising agency), Ecclesiastical (client); Tom West (art director)

Pages 36-39: Copyright widow of Jos de Mey

Page 40: Courtesy of D. Alan Stubbs and Simone Gori

Pages 41-50: Copyright István Orosz

Pages 51 and 52: Copyright Manfred Stader

Pages 53-57: Copyright John Langdon

Page 58: Copyright Ryota Kanai

Pages 59-62: Copyright Catherine Palmer

Pages 63-66: Copyright Ken Knowlton

Page 67: Copyright Walter Anthony

Pages 68 and 69: Courtesy of www.oldpostcards.com and www.ustownviews.com

Page 70: Public domain image

Page 71: Copyright Jim Warren

Pages: 72-75: Copyright André Martins de Barros

Pages 76 and 77: Copyright Stanford Slutsky

Page 78: M. Schrauf, B. Lingelbach, E.R. Wist (1997); redrawn by Akiyoshi Kitaoka (2007) for Visiome

Page 79: Copyright Akiyoshi Kitaoka

Pages 80 and 81: Copyright Jerry Downs

Page 82: Courtesy of Edward H. Adelson

Page 83: Copyright Elena Moskaleva

Pages 84 and 85: Copyright Arvind Narale

Pages 86 and 87: Copyright John Pugh

Pages 88-93: Copyright Chow Hon Lam, aka Flying Mouse

Pages 94-96: Copyright Andreas Aronsson

Pages 97 and 98: Copyright Judy Larson

Page 99: Copyright Hop David

Pages 100 and 101: Copyright Mathieu Hamaekers

Page 102: Copyright Hop David

Page 103: Copyright Robin Reithmayr

Page 104: Copyright JD. Hillberry

Page 105: Copyright Jaime Vives Piqueres

Page 106: Copyright David Swart

Page 107: Courtesy of Frederick Kingdom, Elena Gheorghiu, and Ali Yoonessi, McGill University

Pages 108-111: Copyright Sandro Del-Prete

Pages 112 and 113: Copyright Simon C. Page

Pages 114-129: Copyright Rob Gonsalves; images courtesy of Huckleberry Fine Art, www.huckleberryfineart.com

Pages 130-136: Copyright Daniel Picon

Pages 137-139: Copyright Vicente Meavilla

Page 140: Copyright Christopher Duffy

Pages 141-150: Copyright Gene Levine

Page 151: Copyright Andrew Fling

Pages 152-156: Copyright Valentine Dubinin

Page 157: Copyright Samuel House

Page 158: Courtesy of Pittsburgh Zoo

Pages 159-161: Copyright José María Yturralde

Pages 162 and 163: Copyright Robert Fathauer

Page 164: Copyright Hans de Koning

Pages 165 and 166: Copyright Jos Leys

Page 167: Copyright Paul N. Grech

Page 168: Courtesy of Oona Raisanen

Page 169: Copyright P. Lutus

Page 170: Copyright Merlin Dunlop

Pages 171-173: Copyright Tamás Farkas

Page 174: Copyright Jocelyn Faubert

Page 175: Copyright Nicholas Wade

Pages 176 and 177: Copyright Norman Parker

Pages 178-180: Copyright Lubov Nikolaeva

Page 181: Sculpture by Neil Dawson; photograph courtesy of David Hartley

Pages 182-184: Copyright Monika Buch

Pages 185-187: Copyright Victor Molev

Pages 188 and 189: Copyright Alan King

Page 190: Courtesy of Paul Nasca

Page 191: Copyright Dmitry Rakov

Page 192: Courtesy of Joaquim Alves Gaspar/Wikimedia Commons

Page 193: Public domain image

Pages 194-199: Copyright Gianni A. Sarcone, www.archimedes-lab.org, Italy

Page 200: Copyright Scott Blake

Pages 201 and 202: Copyright Erik Minnema

Page 203: Copyright Fred Eerdekens

Pages 204-208: Copyright Scott Kim

Page 209: Copyright Syd Mannion, Auckland, New Zealand photographer

Pages 210-213: Copyright Dick Termes

Pages 214-216: Copyright David Macdonald

Pages 217 and 218: Copyright David Dory

Page 219: Copyright Jens Malmgren

Page 220: Copyright Gene Levine (bottom four images)

Page 224: Copyright Jens Malmgren; additional graphic manipulation provided by Gary W. Priester

ARTIST WEBSITES

ARTIST	WEBSITE
Edward Adelson	http://web.mit.edu/persci/people/adelson/index.html
Andreas Aronsson	http://www.andreasaronsson.com
André Martins de Barros	http://amdbartiste.free.fr
Scott Blake	http://www.barcodeart.com
Monika Buch	http://www.monikabuch.com
Hop David	http://www.clowder.net/hop/
Sandro Del-Prete	http://www.sandrodelprete.com
David Dory	http://www.daviddory.net
Jerry Downs	http://www.jerrydownsphoto.com
Valentine Dubinin	http://www.valdub.ru
Christopher Duffy	http://www.duffylondon.com
Merlin Dunlop	http://www.impossibottle.co.uk
Fred Eerdekens	http://www.fred-eerdekens.be
M.C. Escher	http://www.mcescher.com
Tamás Farkas	http://www.farkas-tamas.hu/
Robert Fathauer	http://www.tessellations.com
Rob Gonsalves	http://www.huckleberryfineart.com
Simone Gori	http://perceptualstuff.org/dynlum.html
Paul N. Grech	http://www.pngconcepts.com
Mathieu Hamaekers	http://www.thealiencode.info/
J.D. Hillberry	http://www.jdhillberry.com
Scott Kim	http://www.scottkim.com/
Alan King	http://www.kingart.co.uk
Fred Kingdom	http://mvr.mcgill.ca/Fred/fkingdom_home.html
Akiyoshi Kitaoka	http://www.ritsumei.ac.jp/~akitaoka/index-e.html
Ken Knowlton	http://www.knowltonmosaics.com/
Hans de Koning	http://www.hansdekoning.com/
Chow Hon Lam (aka Flying Mouse)	http://www.flyingmouse365.com
John Langdon	http://www.johnlangdon.net
Judy Larson	http://www.judylarson.com
Gene Levine	http://www.colorstereo.com
Jos Leys	http://www.josleys.com
P. Lutus	http://www.arachnoid.com
David Macdonald	http://www.cambiguities.com
Jens Malmgren	http://www.malmgren.nl
Syd Mannion	http://www.sydmannion.co.nz
Ray Massey	http://www.raymassey.com
Erik Minnema	http://www.flickr.com/photos/erik_minnema/
Victor Molev	http://www.victormolev.com
Elena Moskaleva	http://elenamoskaleva.deviantart.com/
Arvind Narale	http://www.upsidedownsideup.com
Rafal Olbinski	http://www.patinae.com
Octavio Ocampo	http://www.visionsfineart.com
István Orosz	http://www.gallerydiabolus.com/gallery/artist.php?id=utisz
Simon C Page	http://www.excites.co.uk
Catherine Palmer	http://www.palmyria.co.uk
Norman Parker	http://www.normanparker.com/
Daniel Picon	http://daniel-picon.over-blog.com
Jaime Vives Piqueres	http://www.ignorancia.org/en/
John Pugh	http://www.artofjohnpugh.com
Stanford Slutsky	http://www.stanfordslutsky.com/
David Swart	http://www.flickr.com/photos/dmswart/
Dick Termes	http://www.termespheres.com
Dmitry Rakov	http://www.rakov.de
Robin Reithmayr	http://robinreithmayr.deviantart.com
Gianni A. Sarcone	http://www.archimedes-lab.org
Manfred Stader	http://www.3d-street-art.com
Nicholas Wade	http://www.opprints.co.uk/
Jim Warren	http://www.jimwarren.com
José María Yturralde	http://www.yturralde.org

ACKNOWLEDGMENTS

In addition to all the wonderful artists appearing in this book, the authors would like to extend special thanks to the following individuals who provided considerable assistance:

Vlad Alexeev of Impossible World (www.im-possible.info)

Scott Kim (www.scottkim.com)

Boots Harris of Huckleberry Fine Art (www.huckleberryfineart.com)

Sherri Nahan of Patinae, Inc. (www.patinae.com)

Gianni A. Sarcone and Marie-Jo Waeber of Archimedes' Laboratory (www.archimedes-lab.org)

Gary W. Priester (www.gwpriester.com)

Christy Davis of Executive Services

Elizabeth Anne Baker

Allan Tubach

Klim Altman of Visions Fine Art (www.visionsfineart.com)

Steve Christian (www.KapanLagi.com)

The authors would also like to acknowledge the following information sources:

Giuseppe Arcimboldo, The Complete Works, http://www.giuseppe-arcimboldo.org/

M.C. Escher, The Official Website, http://www.mcescher.com/

M.C. Escher, Life and Work, THE COLLECTION, National Gallery of Art, http://www.nga.gov/collection/gallery/ggescher/ggescher-main1.html

Martin Gardner, *Mathematical Circus*, chapter 1, Optical Illusions (Knopf Publishing, 1979).

Susana Martinez, 10 TOP ILLUSIONS (in *Scientific American MIND* by Conde and Stephen L. Macknick, May/June 2011).

Pascale Michelon, *Visual Illusions in Art and Science* (*SharpBrains* blog, February 11, 2011, article includes an excerpt from *Sleights of Minds: What the Neuroscience of Magic Reveals about Our Everyday Deceptions* by Stephen L. Macnick and Susana Martinez-Conde, Henry Holt and Co., 2010).

Julian Rothenstein and Mel Gooding, *The Playful Eye* (Chronicle Books, 2000).

Al Seckel, *Masters of Deception* (Sterling Publishing, 2004).

Victor Vaserly, Biography: Leader of the Op Art Movement, Masterworks Fine Art, http://www.masterworksfineart.com/inventory/vasarely/vasarely.php

Brainy Quote, http://www.brainyquote.com/quotes/quotes/m/mcescher107495.html

GENERAL INDEX

Ambigrams, 8, 15, 16
Anamorphosis, 12
Arcimboldo, Giuseppe, 12, 13
Crystallography, 14
Da Vinci, Leonardo, 12
Dali, Salvador, 13
Dark ages, 12
Depth, 5, 6, 12
Double imagery, 12, 13
Double meaning, 12, 13
Escher, M.C., 13, 14
Flat images, 7
Geometry, hyperbolic, 14
Greece, ancient, 11
Group theory, 14
History, of illusions, 11–16
Hofstadter, Douglas R., 15
Mathematical art, 13
Metamorphic art, 13
Moors, 13, 14
Newell, Peter, 16
Op art, 15–17
Perspective, 12, 13
Renaissance, 12, 13
Romans, 11
Slant art, see Anamorphosis
Symmetry, 14
Tessellations, 14
Topology, 14
Trompe l'oeil, 11, 15
Wotherspoon, George A., 13, 14

ARTISTS' INDEX

Adelson, Edward, 82
Anthony, Walter, 67
Aronsson, Andreas, 94–96
Barros, André Martins de, 72–75
Blake, Scott, 200
Buch, Monika, 182–184
David, Hop, 99, 102
Dawson, Neil, 181
Del-Prete, Sandro, 108–111
Dory, David, 217, 218
Downs, Jerry, 80, 81
Dubinin, Valentine, 152–156
Duffy, Christopher, 140
Dunlop, Merlin, 170
Eerdekens, Fred, 203
Escher, M.C., 29–32
Farkas, Tamás, 171–173
Fathauer, Robert, 162, 163
Faubert, Jocelyn, 174
Fling, Andrew, 151
Gaspar, Joaquim Alves, 192
Gonsalves, Rob, 114–129
Gori, Simone, 40
Grech, Paul N., 167
Hamaekers, Mathieu, 100, 101
Hillberry, J.D., 104
Hogarth, William, 193
House, Samuel, 157
Kanai, Ryota, 58
Kim, Scott, 5, 204–208
King, Alan, 188, 189

Kingdom, Fred, 107
Kitaoka, Akiyoshi, 79
Knowlton, Ken, 63–66
Koning, Hans de, 164
Lam, Chow Hon, 88–93
Langdon, John, 53–57
Larson, Judy, 97, 98
Levine, Gene, 141–150
Leys, Jos, 165, 166
Lingelbach, B., 78
Lutus, P., 169
Macdonald, David, 214–216
Malmgren, Jens, 219, 224
Mannion, Syd, 209
Massey, Ray, 33–35
Meavilla, Vicente, 137–139
Mey, Jos de, 36–39
Minnema, Erik, 201, 202
Molev, Victor, 185–187
Moskaleva, Elena, 83
Narale, Arvind, 84, 85
Nasca, Paul, 190
Nikolaeva, Lubov, 178–180
Olbinski, Rafal, 26–28
Ocampo, Octavio, 20–25
Orosz, István, 41–50
Page, Simon C., 113
Palmer, Catherine, 59–62
Parker, Norman, 176, 177
Picon, Daniel, 130–136
Piqueres, Jaime Vives, 105

Pugh, John, 86, 87
Raisanen, Oona, 168
Rakov, Dmitry, 191
Reithmayr, Robin, 103
Sarcone, Gianni A., 194–199
Schrauf, M., 78
Slutsky, Stanford, 76, 77
Stader, Manfred, 51, 52
Stubbs, Alan D., 40
Swart, David, 106
Termes, Dick, 210–213
Unknown, 68–70
Wade, Nicholas, 175
Warren, Jim, 71
Wist, E.R., 78
Yturralde, José María, 159
Zoo, Pittsburgh, 158–161

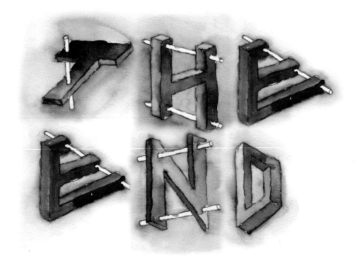

JENS MALMGREN

Impossible Ending, 2011
All good things must come to an impossible end.